MW01113380

MARDI GRAS
in MOBILE

MARDI GRAS
in MOBILE

L. CRAIG ROBERTS

THE
History
PRESS

Published by The History Press
Charleston, SC 29403
www.historypress.net

Front cover, top: Order of Inca, Theme float, 2011. *Courtesy of Steve Joynt / Mobile Mask.*
Front cover, bottom: The King's Float. Mobile Carnival Association's King Felix III
and Queen. *Courtesy of the History Museum of Mobile.*

First published 2015

Manufactured in the United States

ISBN 978.1.62619.728.2

Library of Congress Control Number: 2014953423

Notice: The information in this book is true and complete to the best of our
knowledge. It is offered without guarantee on the part of the author or The
History Press. The author and The History Press disclaim all liability in
connection with the use of this book.

For
the late Madeline C. Partridge
for introducing me to Mardi Gras
and
Rhea S. Mostellar
for the ride

In Mobile, Mardi Gras comes with the seasons, a natural phenomenon, an event to be anticipated and enjoyed, but not really to be considered anything very unusual. One simply grows up knowing that Mardi Gras will come with the spring.
—Caldwell Delaney

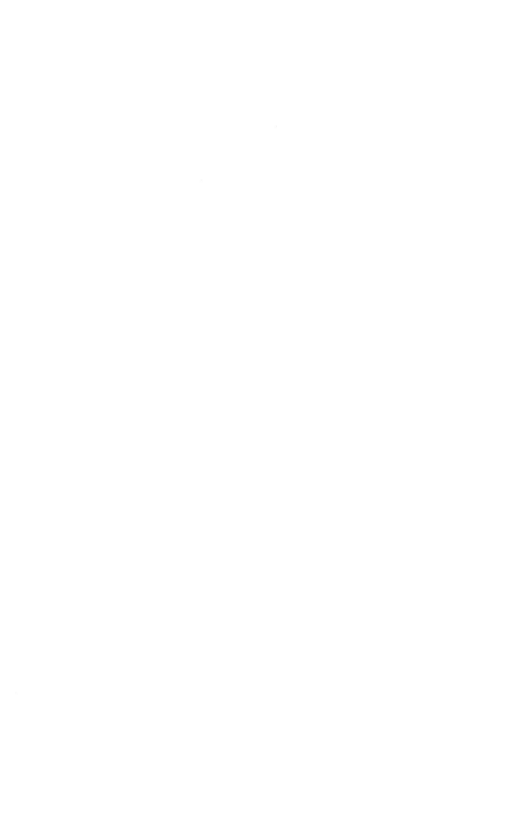

Contents

Preface

Who is that guy over there?" the Old Mobilian asked his friend at a cocktail party. "Why, that's Craig Roberts," his friend responded. "He's the new guy who knows all about Mobile." Mind you, I have been here for forty years! I have also been referred to a "born-again Mobilian." I like this very much!

Not having been born here, much less having generations of family born here, means one is always considered somewhat of a "visitor" in Mobile. Visitors and tourists are treated well in Mobile, with all the Southern hospitality, grace and charm you may not expect, and I have been a beneficiary of this same hospitality, grace and charm for almost forty years. Mobile is my adopted city, and I love her. She is like a well-dressed, beautiful and graceful older lady.

As an architect, I am fascinated by Mobile's volume of restored historic buildings and homes. There are more than six thousand listings and six hundred square blocks of historic districts on the National Register of Historic Places.

Equally fascinating as the architecture is the flora and fauna. Majestic live oak trees—many older than our three-hundred-year-old city—canopy our streets for miles in every direction. On them grow Spanish moss, or what I call "tropical icicles." Also growing on their branches are resurrection ferns, which dry up and turn brown without precipitation but burst forth in bright chartreuse upon the next rain event. It thrills my senses.

Azaleas, the Indian variety, which grow as big as small houses, are profuse with blooms in March. This is when they light up the city with a fluorescent glow of brilliant pinks, reds and purples. I have often remarked that I have to wear sunglasses to protect my eyes from their blinding color.

Interesting creatures abound. I love the banana spiders (*Nephila clavipes*) that grow to five inches long and weave webs that by fall would put any horror movie spider web to shame. Alligators? Yes, we have them. You may even hunt them here at specific times. I like to watch the fifteen-footer that suns just outside the dining room at Felix's Fish Camp. Another wonderful reptile, the green anole lizard (*Anolis carolinensis*), abounds in Mobile. They love to play around your garden sporting their often brilliant green color.

As beautiful as the city is, its greatest treasure may be found in its soul. Its soul is the culture of Mardi Gras. My wish is to open this unique culture to you with this book.

The likely inscription on my Mobile gravestone will read, "Here lies L. Craig Roberts, a native of Guntersville, Alabama, who lived here a good while."

Acknowledgements

As a first-time writer, it was imperative that I seek the help of those who are experts in the field about which I write and are also experts in structuring the written word.

My friends at the Mobile Carnival Museum, where I serve as a docent on most Saturdays, were most helpful. Judi Gulledge, executive director of the Mobile Carnival Association and Museum, shared her knowledge and many years of experience from firsthand involvement with Mobile's Carnival. Edward Ladd, curator of the museum, shared many stories of his involvement with our city's great festival and loaned me many books and photographs to which only he has access. Edward Ladd and Tom McGehee were kind enough to proof "Part I: History of Mardi Gras" for historical accuracy. Tom Van Antwerp was equally kind enough to proof, for accuracy, a chapter in Part II.

Eric Finley, past president of the Mobile Area Mardi Gras Association, provided me with many wonderful memories, as well as valuable insights into Mobile's African American Carnival history. He worked diligently acquiring the answers to my many questions, as well as providing me with the many contacts needed for my research.

A big thank-you goes to Steve Joynt, editor and publisher of "Mobile Mask: The Reveler's Guide to Mardi Gras" (http://www.themobilemask.com) for sharing articles, photographs and professional insights with me.

I am honored to have friends such as Rhea Mostellar, Rich Gudmundson and David Schmohl. Their knowledge of Mardi Gras societies, parades

and the Mobile Carnival Association (MCA) courts was unselfishly shared with me. Equally appreciated was their never-ending patience with me, as I prodded them for information time after time.

The History Museum of Mobile and the Doy Leale McCall and Manuscript Library of the University of South Alabama were generous with their research and time in compiling the many historic photographs I requested and used in this book.

Cartledge Blackwell, with the Mobile Historic Development Commission, was helpful locating important historical photographs.

Mobile's creative world of Mardi Gras design reached out to me, and I will always be grateful to such talented friends as Ron Barrett, Homer McClure and Pat Halsell-Richardson, who opened up their studios, sharing techniques as well as fascinating stories. Craig Stephens and Steve Mussell were so kind to open their "secret" float barns to me, where they are building next year's floats twelve months a year.

Always supportive, my mother, Sue P. Roberts, and sister, Carla R. Hawley, were a great source of positive reinforcement.

My many thanks go to my lifelong friend Forrest Hinton, who tirelessly proofed and corrected my many drafts.

Most of all, my love and appreciation go to my life partner of twenty years, Rob Spicer, for typing page after page of handwritten text and then re-typing edited drafts.

Introduction

I f you read nothing else, read these ten facts about Mardi Gras in Mobile.

1. MARDI GRAS IS THE DAY; CARNIVAL IS THE SEASON.
Mardi Gras means Fat Tuesday in French. It is Shrove Tuesday, the day before Lent begins (Ash Wednesday). Carnival is all the parades, balls and parties leading up to Mardi Gras Day.

2. MOBILE WAS THE FIRST CITY IN THE WESTERN HEMISPHERE TO CELEBRATE MARDI GRAS.
The French settled Mobile first along the Gulf Coast. They had settled Canada before, but it was too cold to have Mardi Gras there.

3. MOST MARDI GRAS PARADES PRECEDE A BALL.
Balls and parades are sponsored by mystic societies, or krewes, and paid for privately. Over 100,000 guests attend Mardi Gras balls, and over 1 million attend parades each year in Mobile, making Mobile's Mardi Gras the second-largest community festival in the nation each year.

4. FORMAL ATTIRE, CONSISTING OF GOWNS TO THE FLOOR FOR WOMEN AND WHITE TIE AND TAILS FOR MEN, IS REQUIRED AT BALLS.
This is called costume de rigueur. No military uniforms or colored accessories are allowed for men. Daytime balls, called receptions, require cocktail dress and coat and tie.

5. COSTUMING ANYTIME DURING CARNIVAL IS LIMITED TO THE MASKED RIDERS ON FLOATS AND OTHER MEMBERS OF MYSTIC SOCIETIES AT THEIR BALLS.
The public participates on a very limited basis, usually wearing decorative masks on Joe Cain Day or Mardi Gras Day only, but there are no official restrictions.

6. THERE ARE TWO ROYAL COURTS OF MARDI GRAS RUN BY THE MOBILE CARNIVAL ASSOCIATION (MCA) AND THE MOBILE AREA MARDI GRAS ASSOCIATION (MAMGA).
Each association is separate and distinct from the many mystic societies and selects its Royal Courts from Mobile families who have been involved with Mardi Gras and the Royal Courts for generations.

7. THERE ARE FOUR PARADE ROUTES, BUT 95 PERCENT OF ALL PARADES FOLLOW ROUTE A.
Route A is a two-and-a-half-mile path snaking through Mobile's Central Business District. If you are downtown during Carnival, it would be hard to miss a parade. Parades roll for nineteen days in a row except for two days, which are reserved for parades cancelled due to rain.

8. IN MOBILE, THE COLORS OF MARDI GRAS ARE PURPLE AND GOLD. NO GREEN.
Green was a New Orleans after-the-fact addition in the 1880s.

9. YOU SHOULD SCREAM FOR MOON PIES AND BEADS THAT ARE THROWN FROM THE PARADE FLOATS.
It is the only sure way to catch the goodies, unless you are lucky—or very good-looking!

10. DO NOT MISBEHAVE.
You will be arrested for inappropriate or illegal conduct. Mobile's Mardi Gras is a family event!

Part I

HISTORY OF MARDI GRAS

Chapter 1
Ancient Festivals

The Early Roots of Mardi Gras

Many present-day religious-based festivals started as pagan, or secular, celebrations. An early Egyptian celebration held during the month of February has been termed a primitive crop-growing festival. It is believed that five thousand years ago, this festival spread into what is now France. There the Druids held an early spring festival at which they sacrificed a young bull, which was called *boeuf gras*, meaning fatted calf. This festival was Fête du Soleil, or Festival of the Sun.

When the Romans conquered most of what is now Europe, they embraced an old Greek festival, calling it Lupercalia. This event was held every year on or about February 15 until the end of the fifth century. At this celebration, the tradition was to sacrifice a fatted ox. It was yet another late winter or early spring festival.

As the Romans accepted Christianity and over time formed the Roman Catholic Church, an attempt was made, in order to accelerate conversions, to change the old "fatted ox" celebration into a more Christian celebration connected to their season of Lent. Thus Carnival, as we know it, was born.

Carnival derives from the Latin word "carnal" and means "farewell to meat" or "farewell to flesh." Meat was a luxury to be "given up" or sacrificed for God during the Lenten period. At that time, the populace did not have sugar, so there were no cookies, cakes, candy or ice cream to give up. Because water was often dangerous, alcoholic beverages were considered essential and thus were not given up either.

Carnival season was established to begin the day after the Epiphany, with the evening of the Epiphany being known as Twelfth Night, or today January 6, twelve days after Christmas—the day the Magi (wise men) reached their destination. In Mobile, the Carnival season was extended to the American Thanksgiving holiday.

The season ends with the beginning of the Lenten season in several Christian denominations. On Ash Wednesday, many Christians receive ashes on their forehead to mark the beginning of the Lenten season. The day before, Mardi Gras Day, is the first Tuesday beyond forty-seven days before Easter, and Easter is the first Sunday after the first full moon, after the Vernal Equinox, the first day of spring. Got that?

Tuesday before Ash Wednesday, Mardi Gras Day, is known as Shrove Tuesday. Shrove derives from the word "shrive," which means "to confess."

Roman Catholics and Anglicans (later known as Episcopalians in America) began to realize that the day before the forty-seven days of Lenten praying, fasting and soul searching might be a good day to "party hearty."

Shrove Tuesday became known as Mardi Gras Day. It was on Mardi Gras Day in Paris during this time period that the *boeuf gras*, or fatted calf, was introduced again as a paraded spectacle. This, by some, may be interpreted as the beginning of Mardi Gras parading.

In 1817, Lord Byron wrote:

> *'Tis known—at least it should be—that throughout*
> *All countries of the Catholic persuasion*
> *Some weeks before Shrove Tuesday comes about.*
> *The people take their fill of recreation*
> *And buy repentance—ere they grow devout—*
> *However high their rank, or low their station,*
> *With fiddling, feasting, dancing, drinking, masking,*
> *And other things, which may be had for asking.*

It should be understood that festivities related to Carnival or Mardi Gras Day are not officially connected to or sanctioned by any denomination. These celebrations are created mostly by Catholics and Anglicans and are timed to coincide with certain church doctrines and traditions.

The events of Carnival and Mardi Gras Day diminished and then were resurrected over time depending on the occasional revolution or whims of rulers in Europe. An example is the French revolution of 1789, which effectively ended pre-Lenten festivities. However, when Napoleon

Bonaparte became emperor in 1804, celebrations were restored, and Carnival became more elaborate than ever.

The same has held true in recent times when Carnival has ceased during periods of great wars but returned larger and grander each time.

Chapter 2
Pre–Civil War Mardi Gras

Charles le Moyne de Longueuil et de Châteauguay of France settled Canada in 1641. In 1632, a Frenchman named René-Robert Cavalier, Sieur de La Salle, explored the Great Lakes region and discovered the northern beginnings of the Mississippi River. He led an expedition to the lower Mississippi but never reached the mouth of that mighty river.

In 1698, King Louis XIV sent two sons of Charles le Moyne, whose names were Pierre le Moyne, Sieur de Iberville, and Jean Baptiste le Moyne, Sieur de Bienville, to claim the Mississippi Delta for France. After all, those empire-minded Spaniards had claimed the area of what is now Pensacola, Florida, in 1698. Bienville was only eighteen years old, and his older brother, Iberville, was thirty-seven.

In March 1699, the two brothers set up camp on what is now Dauphin Island, Alabama. They called it Isle du Massacre, or Massacre Island. Here they found skeletal remains of Indians strewn about as if a great battle had taken place. In reality, it was an Indian burial site that had been unearthed, it is believed, by recent hurricanes. This site became French headquarters for the colonization of the Gulf Coast.

In 1702, Bienville established the settlement of Fort Louis de la Mobile, named after King Louis XIV, the Sun King, and declared it the capital of the French province of Louisiana. They called Mobile La Mer Mystic, or the Mother of Mystics, where in 1703 it is believed the first Mardi Gras celebration was held in the New World. Mobile has called itself the Mother of Mystics ever since.

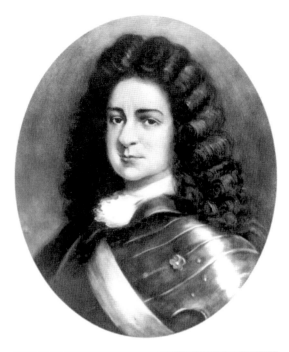

Historians tell us that in 1704, Nicholas Langois established the Societé de Saint Louis at the new settlement of Mobile located at 27 Mile Bluff, sixteen leagues above the mouth of Mobile Bay. The Societé de Saint Louis is believed to be the first mystic society, a form of social club, in the New World. Its first Carnival celebration that year was called Masque de la Mobile. This society held its last celebration on Mardi Gras Day in 1842 after surviving 138 years, almost as long as our oldest present-day societies.

Fort Louis and Mobile were moved to the top of Mobile Bay at the mouth of the Mobile River in 1711. This year, it is believed, Nicholas Langois founded the La Boeff Society. This mystic society lasted until

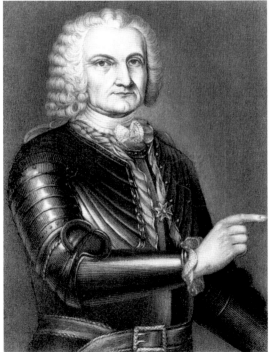

Top: Pierre Le Moyne, Sieur de Iberville, circa 1700. *Alabama Department of Archives and History.*

Left: Jean Baptiste le Moyne, Sieur de Bienville, circa 1700. *History of Mobile Museum Collection, the Doy Leale McCall Rare Book and Manuscript Library, University of South Alabama.*

1861, the first year of the Civil War, when its emblem, a huge bull's head, was dismantled and used for Civil War cannon wadding. It is said that the term "shooting the bull" grew out of this sad end to the society's great symbol. Fort Louis was renamed Fort Conde in 1720.

In 1773, the Spanish Mystic Society was formed and lasted until 1833, a total of sixty years. It paraded in Mobile on Twelfth Night, January 6, the Feast of Epiphany.

After being founded in 1718, New Orleans also had mystic societies, which were later called krewes. These old societies held lavish balls on Shrove Tuesday in New Orleans, as an end to Carnival season, and in Mobile on New Year's Eve or Twelfth Night, considered the celebratory beginning of Carnival season.

As cotton became "king" in the early 1800s, the South and its port cities, in particular, became extraordinarily wealthy. It is said that what happened in the second half of the twentieth century to Middle Eastern countries with oil wealth is what happened to the South during the first half of the nineteenth century with cotton wealth.

Mobile's population was growing exponentially, adding almost 1,000 inhabitants each year between 1830 and 1860. According to the 1830 census, Mobile had 3,194 persons and 29,258 by 1860, 7,587 of whom were slaves. Half of the population was locally born, and half had been born in the North or in a foreign country. By 1860, Mobile was the fourth-largest city in the South yet was the third-largest banking center and third-largest exporting port in the United States.

During this time of growth and prosperity, Carnival celebrations began to become the elaborate affairs we enjoy today. None of the mystic societies held parades with themed floats preceding their balls, as is done during today's Carnival season. In 1830, however, what later evolved into modern-day parading began with a group of Mobile men ending their evening with a little overindulgence.

On New Year's Eve 1830, Michael Krafft, a handsome one-eyed cotton broker, originally from Bristol, Pennsylvania, and a few friends had dinner at the famous La Tourette's Restaurant. About midnight, walking home together, they "raided" Partridge Hardware Store. They took rakes, cowbells, hoes and gongs, which were used as musical instruments, clamoring against the iron fence railing as they proceeded through the streets, eventually reaching the mayor's home, where they were invited in for breakfast. The first procession of the antebellum Carnival season was born. In 1890, T.C. DeLeon wrote, "This was the acorn; a very little one from which was to

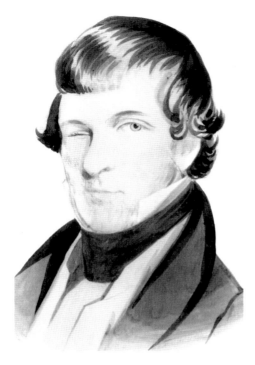

Michael Krafft, circa 1830. *Historic Mobile Preservation Society.*

spring the perfected pageantry of all the intervening years; out of which came the creole carnival now existent and known, by name, wherever Americans read, or travel."

These fun-loving men formed the Cowbellion de Rakin Society, which is French for the Cowbell and Rake Society. As always, the translation sounds so much more eloquent in French! By 1840, these Cowbellions had added themes with floats to their procession. The first theme was "Heathen Gods and Goddesses." This was the first Mardi Gras parade in the form that we know them today.

For their ceremonies, the "Cows," a wealthy group of men, ordered a five-gallon silver bowl for several hundred dollars from French silversmiths, who took one year to make it. On its sides was the insignia of the Cowbellions: an owl, a rake, a cow's head and a torch.

The bowl was filled with eggnog, which the men drank from a bull's horn. A portion of the original bowl, partially destroyed by fire, is today the proud possession of the Order of Myths, the country's oldest Mardi Gras parading society.

The following is a list of the parade and ball themes of the Cowbellion de Rakin Society before the Civil War. The sophistication of the themes rivals those of today.

1840: Heathen Gods and Goddesses
1841: Modern Costumes
1842: Olympus
1843: Costumes and Characters of Different Nations
1844: Modes of Warfare and Arms of Different Nations
1845: The Pastimes of Past Times

1846: Shades of the Past
1847: The Animal Kingdom
1848: Fancy Costumes
1849: Chinese Feast of Lanterns
1850: Old Sports and Pastimes of Merry England
1851: The Principle Characters of Shakespeare
1852: Heathen Mythology
1853: The Dream of Pythagoras
1854: The Progress of Nations Toward Liberty
1855: Animated Flora and Vegetable Kingdom
1856: Pandemonium Unveiled
1857: The Game of Life and Death
1858: Artisans' and Tradesmens' Convention
1859: Scandinavian Mythology
1860: Ludicrous Contrasts of the Past and Present as Seen by our Most Ancient Cow
1861: Carnival of Venice

The Cowbellions paraded on New Year's Eve until the Civil War, when all Carnival parading was canceled. These men had secured their membership from the beginning and refused new members, including their own sons. Their last parade was early in the 1880s, when they all died off.

Also parading on New Year's Eve was the Tea Drinkers Society (TDS), which was founded by a group of teenagers, including little Joseph Stillwell Cain, later to become Mobile's most famous native. They paraded until the Civil War and afterward until the early 1880s.

The sons of the Cowbellions and their friends formed the Strikers Independent Society, now known simply as the "Strikers," in 1842. These young men often worked for their fathers, who owned cotton brokerage firms and cotton bale warehouses where these young men, as part of their job, counted the bales of cotton by striking them with chalk. Calling their dads "old goats" for not allowing them to join their Cowbellion Society, these sons chose a goat for their mascot. The life-size wooden goat used for their initiations since 1871 is on display today at the Mobile Carnival Museum. Sotheby's auction house of New York has deemed this antique to be priceless.

Also on display at the museum is the "Striker's Table." This ornate table from 1850 features hand-carved alligator heads as feet, goats holding up the table top and an inscription on top reading *Bis dat tui cito dat*," which is the Striker's motto and translates to: "He gives twice who gives quickly." The table was originally a

The Strikers' den since 1964 was formerly a garçonnière for the Nugent and Waring families, 110 South Claiborne Street, erected in 1840. *Author's collection.*

gift to the Orphans Fair for a raffle and is certainly an indication of the generosity of the society. The odd thing about the table is that it was made in Edinburgh, Scotland, and in truth, the alligator heads look more like platypus heads. Maybe in the 1840s, these Scottish carvers did not know what an alligator looked like, and instead of goats, they carved rams. This table is the oldest piece of Mobile Mardi Gras memorabilia in existence.

Father Abram Ryan, famous poet priest of the Confederacy who lived in Mobile for a time following the Civil War, wrote the following poem expressing thanks to the Mobile mystic societies for their charitable giving:

> *The olden golden stories of the world,*
> *That stirred the past,*
> *And now are dim as dreams,*
> *The lays and legends which the bard unfurled*
> *In lines that last,*
> *All—rhymed with glooms and gleams.*
> *Fragments and fancies writ on many a page*
> *By deathless pen,*

And names, and deeds that all along each age,
Thrill hearts of men.
And pictures erstwhile framed in sun or shade
Of many climes,
And life's great poems that can never fade
Nor lose their chimes,
And acts and facts that must forever ring
Like temple bells,
That sound or seem to sound where angels sing
Vesper farewells;
And scenes where smile are strangely touching tears,
'Tis ever thus,
Strange Mystics! In the meeting of the years
Ye bring to us
All these and more; ye make us smile and sigh,
Strange power ye hold!
When New Year kneels low in the star-aisled sky
And asks the Old
To bless us all with love, and live, and light,
And when they fold
Each other in their arms, ye stir the sight,
We look, and lo!
The past is passing, and the present seems
To with to go,
Ye pass between them on you mystic way
Thro' scene and scene,
The Old Year marches through your ranks, away
To what has been,
The while the pageant moves, it scarcely seems
Apart of earth;
The old year dies—and heaven crowns with gleams
The New Year's birth.
And you—you crown yourselves with heaven's grace
To enter here;
A prayer—ascending from an orphan face,
Or just one tear.
May meet you in the years that are to be
A blessing rare,
Ye pass beneath the arch of charity,

Who passeth there
Is blest in heaven, and is blest on earth,
And God will care,
Beyond the Old Year's death and New Year's birth,
For each of you, ye Mystics! everywhere.

Strikers' Goat. Photograph from *A History of the Strikers 1842–1997*. Mobile Carnival Museum Collection.

Some of the Strikers had moved to New Orleans in the mid-1800s. New Orleans had become the sixth-largest city in the nation, with 165,000 residents by 1860. This was where the really big money was being made, and it proved to be an irresistible draw for many young men in the Deep South.

These young men asked their Mobile friends to travel 135 miles west to New Orleans and help them transform a parading society into a themed float parading society. As published by TheMobileMask. com in 2014, their actual invitation read: "We herewith extend to you the open hand of brotherhood and friendship and do cordially invite you, as a body, or as individuals, to attend as our guests."

In 1857, some of the Strikers and, it is believed, some of the Cowbellions traveled west and helped their New Orleans friends, members of the Mystic Krewe of Comus, present their first float parade.

New Orleans had been holding its Carnival balls and processions on Mardi Gras evening, and on that night in 1857, the Mystic Krewe of Comus held its first themed float parade: "Gods of Festive Mirth" from Milton's *Paradise Lost*.

The Strikers, who still hold a ball today but no longer parade, remain the oldest Carnival society in the United States and are the third-oldest social organization in the country. The Strikers are exceeded in age only by the Honorable Artillery Company of Boston, Massachusetts, and the St. Cecilia Society of Charleston, South Carolina.

In Mobile, there were three other mystic societies consisting of young men who paraded on New Year's Eve, who prided themselves on being "workingmen." They paraded in 1844, 1845 and 1846. These were the Calfbellions, whose members were butchers; the Indescribables, who were firemen; and the Jim Oakes, who were steamboat men. They all paraded on foot without floats.

During the American Civil War from 1861 to 1865, Carnival parading and most festivities ended. With the defeat of the Confederacy, the great Southern port cities were thrown into financial ruin and mental despair. However, in a short time, Mobilians were ready to get on with life—and reclaim Carnival!

Strikers' Table. Photograph from *A History of the Strikers 1842–1997. Mobile Carnival Museum Collection*.

Chapter 3
Post–Civil War Mardi Gras

The City (Mobile) is a sad picture to contemplate. The people look sad and sorry. The best people of the City are poor and poorly clad. Store shelves are forsaken of their silks and occupied only with the flies and the dust. The people are distressed. No money except coin and greenbacks will pass. They have little of the former—none of the latter. The stores are empty and forsaken, except here and there an old man seated like some faithful sentinel at his post.
—Cincinnati Daily Commercial, *May 5, 1865*

Joseph Stillwell Cain was born on Dauphin Street in Mobile on October 10, 1832. His parents had moved to Mobile from Philadelphia, Pennsylvania, in 1825. Cain was infatuated with the various Carnival and social organizations in the city and became a charter member of the Tea Drinkers Society (TDS) at age thirteen. None of the young men who formed the TDS was over sixteen years old. Their parents speculated that TDS stood for "The Determined Society." However it wasn't long before the boys revealed their real name, claiming they "didn't dare drink anything as weak as tea!" They shunned elitist society drinks, such as eggnog and champagne, choosing instead lager beer as their "common man's" traditional beverage. It was their "everyman" popularity that presented no barrier to a young man's entrance into Mobile Carnival life. They paraded each New Year's Eve until the war and afterward until the early 1880s.

When the Civil War ended, Union troops took control of the city. Mobilians, first led by Joe Cain, were determined to have a little

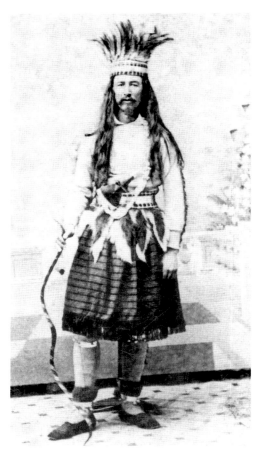

Joseph Stillwell Cain, pictured on April 21, 1866. *Courtesy of Marshall Carney, Olwell Photo, the Doy Leale McCall Rare Book and Manuscript Library, University of South Alabama.*

Mardi Gras fun despite their presence. Joe and most of his friends had served in the Confederate army. He had lived briefly in New Orleans after the war but returned to Mobile in 1866, determined to revive Carnival celebrations in Mobile. He preferred the way New Orleans celebrated up to and on Mardi Gras Day, as a great culmination of the pre-Lenten season.

In 1866, he and six original members of the Tea Drinkers Society decided Mobile needed a little Mardi Gras Day tomfoolery. They dressed as a Chickasaw Indian war tribe, all the while wearing their Confederate uniforms under their costumes. Joe proclaimed himself Chief Slacabamarinico (slaka-BAM-orin-ah-CO), a fictional Chickasaw Indian chief, supposedly from Wragg Swamp, which is west of mid-town Mobile, now filled in and the site of Mobile's major malls and shopping centers. Mobilians often refer to the chief simply as "Ol' Slac."

The Chickasaw Indians were never defeated in battle by French or American troops. As they paraded through the streets with Joe atop an old coal cart lovingly named "Hickory" after their hero Andrew Jackson, they were clanging anything they could use to make loud noises. They were "giving it" to the Yankees occupying the streets in their federal uniforms, saying, "You'll never defeat us again, just as the Chickasaws were never defeated, and the South may have been defeated in war, but we're not crushed or conquered!"

The following year, Cain and his friends appeared again on Mardi Gras Day. Ol' Slac wore a tall plumed hat, a swallowtail coat with big brass buttons and red knee boots with spurs. He carried a big bass drum as big as he, it was said, on which was written "The Lost Cause Minstrels." This name, to be sure, was a reference to the lost cause of the "War of Northern Aggression."

In 1868, Joe appeared for the third time on Mardi Gras Day, again as Chief Slacabamarinico, leading the Lost Cause Minstrels, who were dressed as monkeys. One newspaper reported:

> *Notwithstanding the rain yesterday, Mardi-Gras was celebrated with great spirit. Early in the evening much curiosity and merriment was caused by the appearance of the Minstrel band of the L.C.'s. The Minstrels, who were gotten up as monkeys, were mounted upon a dilapidated wagon, and discoursed wild, and, we must say, discordant music. They were followed by large crowds of boys, shouting and yelling, and presented a most ludicrous and laughable sight. After traversing different parts of the city, they halted in front of our office, and regaled our ears with a monkey serenade.*

Joseph Cain is credited by some historians with not only being a founding member of the Tea Drinkers Society and the Lost Cause Minstrels but also having influenced the founding of some of the oldest mystic societies in existence to this day. It has been written that he—along with other members of the TDS, Lost Cause Minstrels, Cowbellions and Strikers—helped found the Order of Myths (OOM), today the oldest Mardi Gras parading society in the country. He is also credited with convincing Dave Levi, founder of the Comic Cowboys (1884), to take his vaudeville show to the streets as a parade.

Cain had been a cotton broker, volunteer fireman and city clerk and had worked in the coroner's office. He retired to Bayou La Batre, a fishing village just south of Mobile, to live with his son. However, he participated in Mobile's Mardi Gras celebrations until his death in 1904. He was buried in Oddfellows Cemetery just outside that sleepy little village. In 1966, he was exhumed and moved by city proclamation, along with his wife, Elizabeth, into Mobile's oldest cemetery, Church Street Graveyard.

It was Julian Lee Rayford's *Chasin' the Devil Round a Stump*, published in 1962, that revived the memory of Joe Cain and led to the present-day celebrations of his life and brought about his being moved to Church Street Graveyard in downtown Mobile. Rayford wrote, "Here was a genuinely great man, the greatest man in the entire sweep of Mobile's history. No private citizen anywhere in the United States since 1600 has made more

Order of Myth's den since 1950, formerly Bush-Mahr House/Bush-Sands Memorial, at 254 St. Anthony Street, erected in 1840. *Author's collection.*

of an impact on a community—or left a more enduring impression of his personality. All the half a hundred great events of Mardi Gras since 1866 grew out of Joe Cain."

Aristede Hamilin is credited with organizing the Order of Myths, today America's oldest parading Mardi Gras society, along with Harry Pillans, Wallace John Parham, R.B.T. Parham and Clement B. Gwin in 1867. The society's motto is "A little nonsense now and then is relished by the wisest men."

Rayford's *Chasin' the Devil Round a Stump* is a takeoff of the bitterly iconic act of defiant celebration. Borrowing from a medieval symbol of an oblivious fool running to his destruction, the Order of Myths (OOM) adopted a combination of the fool, as a folly, chasing the devil, as a skeleton, around a broken column. This emblem expresses the sentiment, "We will never be defeated again, and to ensure this, no matter how foolish we appear, we will survive and beat Death, defeat and destruction out of the South forever."

Each year, the first float of the last and oldest parade of Carnival on Mardi Gras evening appears lighted by gas flambeauxs and pulled by mules, just as was done in the nineteenth century. Upon the float sits the broken column around which Folly chases Death, beating him over the head with pig's bladders, inflated and painted gold. What a sight it is to behold! The most iconic symbol of Mobile Mardi Gras slowly makes its way along the two-and-a-half-mile parade route while 250,000 onlookers scream and cheer it along.

A lithograph depicting Folly and Death leading an Order of Myths parade was produced by famous float designer Edmond Carl deCelle and given to members as a favor for the 100th anniversary of the organization. One is on display at the Mobile Carnival Museum in Emblem Hall.

Historians believe that not long after the OOM's founding, there was an attempt to merge with the old Cowbellions. The newly

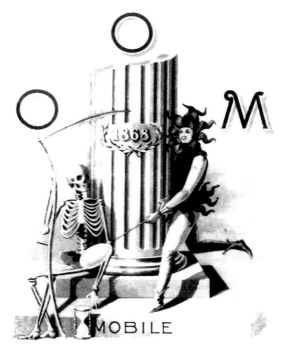

Order of Myths emblem, by Morton Toulmin, circa 1868. *Mobile Public Library, the Doy Leale McCall Rare Book and Manuscript Library, University of South Alabama.*

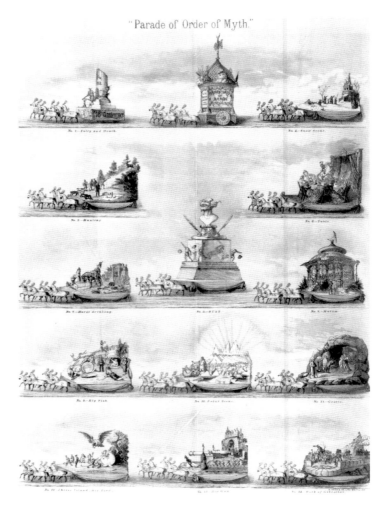

Order of Myths parade design, 1884. *City Museum Collection, History Museum of the City of Mobile.*

merged society would be called the MKA, which stood for the Michael Krafft Association. Records in the City of Mobile Museum reveal the following document by the first president of the Order of Myths, which states in part:

> *After an experiment of five years, of the utility and practicability of the union of the Cowbellion de Rakin Society and the OOM's as a joint society, under the name of the MKA; we the undersigned, members of the Cowbellion de Rakin Society, deem it advisable for the interest of both*

societies, to dissolve this union; leaving it to the members, elected since the union, to join either society, or remain members of both, as per agreement made at the time of the union. For that purpose, we request our Captain to ask the Captain of the MKA to call a meeting of the Ass'n for the express purpose of effecting this dissolution in good faith and fellowship.

In the early 1880s, the last parade of the Cowbellion de Rakin Society and the Tea Drinkers Society was held as a joint parade and was the last of the old New Year's Eve parades. Interestingly, this parade was cancelled due to abnormally cold weather and was held later on the Epiphany, January 6.

Shortly after the formation of the Order of Myths, a group of young men, eighteen to twenty-one years of age, too young to have fought in the Civil War, formed the HSS. The group's motto was *"Hoc Signo Sustineat,"* meaning "In This Sign Sustains." The emblem reflected in the group's motto was a cotton bale and knightly figure along with an elephant, symbol of undying chivalry, and a hissing cat, symbol of all things mysterious and secretive.

The group's first parade was in 1870 and its last in 1873, when it changed its name to the Infant Mystics (IM). This name, aside from the meaning of new birth, also referred to the youthfulness of its members. The preamble to the group's new constitution as the Infant Mystics from 1873 reads:

We the undersigned young men of Mobile being desirous of forming ourselves into an association to succeed the H.S.S., deceased, in the celebration of Mardi Gras by a street carnival and ball for the promotion of our own sociability [sic] and pleasure and also the advancement of the interest of Mobile and to render her more attractive to the outside world and the rest of mankind, agree to adopt for our government the following constitution.

These young men were dedicated to impressing the city and beyond with innovative pageantry and float design. On February 17, 1874, they introduced calcium lighting, recently created for railroad locomotives to light the view ahead. This lighting cast a dazzling brilliance over the floats and streets! Their 1880 parade is regarded as one of the greatest parades of the nineteenth century. The theme, "The March of Ages," consisted of twenty-one grand floats, as many as some present-day parades.

The following is from an editorial that appeared in the *Mobile Register* around 1885:

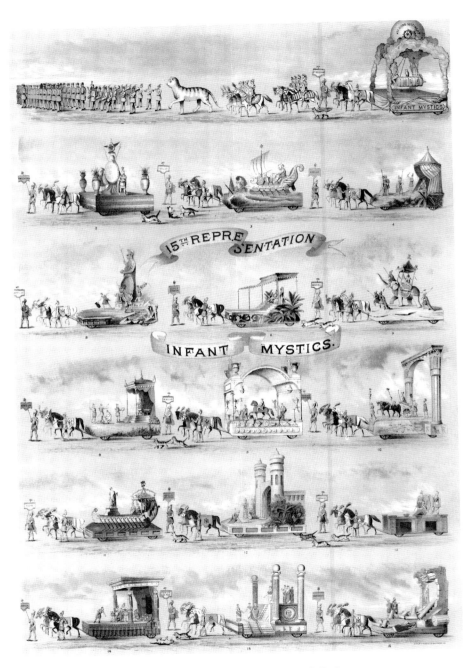

Infant Mystics parade design, 1894. *Mobile Carnival Museum Collection.*

The Infant Mystics came before the public almost unheralded, and their appearance was somewhat a surprise to all except a few confidential friends. At that time, they were looked upon in some quarters as "a party of boys whose mothers did not know they were out," and opinions in regard to them in this respect soon underwent a radical change. They steadily improved, and each representation extended its predecessor in some important particular, and now, the society stands as an established favorite among Mobile masqueraders.

The IMs were the first to introduce members to the guests of a ball with what is known as the tableau. A tableau is a staged theatrical introduction of mystic society members, often with elaborate sets, and it may even include pyrotechnic displays.

Another innovation of this organization was more recent: it introduced doubloons to Mobile Mardi Gras in 1965. These coins, mimicking Spanish doubloons minted of aluminum, are thrown to the crowds at parades or to guests at balls by most mystic societies. On one side is the organization's name, year of founding and the emblem. On the other side is the year of the parade or ball. Members often receive a bronze doubloon as a memento of the year, while the leader of the organization for the year may receive a sterling silver or gold doubloon.

The Infant Mystics played another important role in Mobile's Carnival history with the early organization of the older of Mobile's two Carnival associations: the Mobile Carnival Association (MCA). The Mobile Carnival Association, largely associated with selection of one of the two Royal Courts of Mobile, was founded in 1872 and was, by 1881, in financial trouble when it asked the Infant Mystics to take control of the organization. These young men are credited with reinventing the association into a successful part of Carnival season. It is for this reason that, to this day, the King and Queen of the MCA make a grand entrance during the tableau of the Infant Mystics Ball each year.

It is of note that early Carnival mystic societies' memberships were of men only, and the Strikers and Infant Mystics were single men's societies. Because these bachelor societies were made up of young men of marrying age, it was at times difficult to maintain full membership rosters. Most of these men were from well-to-do families. The original Infant Mystics dues were $3.00 per month, initiation fees were $5.00 and the penalty for an absence from a meeting was $0.25. Conduct unbecoming a gentleman was a fine of $1.00, but, heaven forbid, absence from a parade was a whopping $25.00 fine, about $500.00 today.

The Knights of Revelry (KOR) were founded in 1874 and made their first appearance on Mardi Gras Day in 1875 as the first daytime parade. The group's ball following the parade was referred to as a "reception," as daytime balls are called. With their first parade, the Knights of Revelry members established the reputation of being masters of the Serio-Comic Parade style. John Gus Hinds created this float theme and produced KOR floats for fifty years. These men are credited with making Mardi Gras Day a day of pleasure and fun.

The KOR parade is the only one that has a float ridden by a single masker, "Folly," dressed in a sportive blue-and-silver jester's costume, riding solo in a giant silver champagne cup at the head of a fourteen-float procession. According to J. Walt Haynes on February 16, 1999:

> *Folly is a unique, energetic carnival character using upwards of two hundred bladders, three tied to a stick, to sound his call for making merry over the course of his pre-Lenten ride, reception and Revel.* [Initially, these were pig bladders, which became smaller over time. A switch was made to larger cow bladders.] *In early historical times, Folly utilized a stick which he slapped, making a slapping sound and hopefully some laughter. This was called slapstick and over time, pig bladders were added. Thus, the term "slapstick comedy" was derived.*

Even though the Knights of Revelry have a reception following their parade, they also had a formal ball after Easter known as the Easter Revel. This mystic society, the third-oldest parading society in Mobile today, has opened and closed the Lenten season for over a century. Its parades are always a magnificent display of creativity. Children always look forward to the lead float, still pulled by mules, followed by family friendly themed floats. T.C. deLeon in 1890 said, "The KOR in daytime parades each year peculiarly designed in serio-comic vein—have caught the public with hold as tenacious as la grippe, while far more pleasant in reminiscence."

The most unique parading group of Carnival, the Comic Cowboys, founded in 1884, is still parading on Mardi Gras Day. It was founded by one of Mobile's most colorful citizens and vaudeville entertainers, Dave Levi, who took his vaudeville shows and turned them into a parade. He took on anyone who wanted to join as long as they were willing to have a good time and formed the Comic Cowboys, inspired by one of his shows titled "The Carver Wild West Show." It was alleged these men had their headquarters deep in Wragg Swamp, as mentioned earlier, home to all sorts of strange and mystical men and beasts.

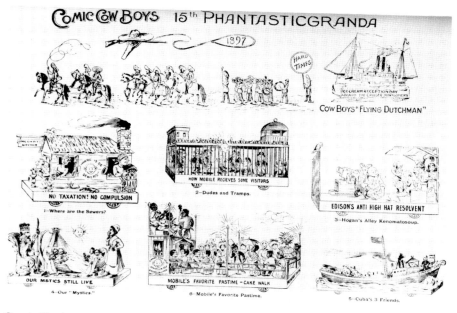

Comic Cowboys parade design, 1897. *Mobile Carnival Museum Collection.*

Wragg Swamp was west of Mobile and later was filled in for today's malls and shopping centers. As vaudeville shows made fun of people and politics of the day, these gentlemen decorated their wagons, now trailers, with satirical signs and rode in sometimes preposterous costumes.

In *Without Malice: The 100th Anniversary of the Comic Cowboys, 1884–1984,* author Sameel Eichold wrote, "These men are the best at focusing light on current absurdity that is related to politics, business, national events, or personalities about town." Some historians have stated that, because Dave Levi and his friends were Jewish, poking fun at the elite Christian balls, parades and Royal Courts was their way of getting back at the organizations that excluded them. It was but a few years later, however, that several prominent Jewish men formed their own mystic society. Even though their motto is "Without Malice," there are those who would say these guys can be quite malicious!

In the Comic Cowboy parades today, after the Emblem float, pulled by mules, appears the annually selected Queen on her float. The "Queen" is always a man dressed as a woman, usually with a five-o-clock shadow and a cigar. This is Queen Little Eva. She has a toilet seat as her throne and a toilet plunger as her scepter. You see, the group is actually poking fun at the highbrow Queens of the various mystic societies and Carnival associations.

The "Cowboy of the Year" follows on a covered wagon float, followed by ten more "floats"—actually trailers pulled by vans or pickups today—each with their satirical two-sided mini billboards. Young boys ride with Little Eva as her Pages on little two-by-four sawhorses, and riders on the other floats are often randomly selected folks, just as was done 130 years ago.

The Order of Myths, Infant Mystics, Knights of Revelry and Comic Cowboys are all early parading groups of the post–Civil War era that remain with us today. The Strikers Independent Society, the oldest mystic society in the country, held its last parade in the early 1880s but has a ball to this day.

The *Mobile Daily Register* of February 14, 1872, described parades of this time:

> *One by one the maskers came forth, and in a short while the streets were alive with all kinds of ridiculous and grotesque figures, each seeming to vie with the other in arriving at the most extravagant absurdity and cutting up the most fantastic tricks and capers. Turks, Chinamen, Arabs, Indians, Africans, and representatives of every race and country, not forgetting the Darwinian ape, the devil and his wives, all mingled together in the most incongruous confusion, with such frequent absurdities of association as to afford unbounded amusement and merriment to all.*
>
> *And so ended Mardi Gras; a day that should be a red letter one in the joyous calendar of the Queen City of the Gulf; for it flowed over not only with merriment and beauty, but with works of Love and Charity that wrought in shining letters above all: "Peace and good will to all men!"*

One of the oldest Mardi Gras balls in Mobile is the Athelstan Double Rush Ball, held just before Christmas since 1875. It is sponsored by the Athelstan Club, a gentlemen's club, not a mystic society.

There are several post–Civil War mystic societies surviving today that only hold balls. One of these is the society that goes only by SCS, later known as the Santa Claus Society, founded in the late 1800s by fifteen prominent young men. Their first ball was in 1890. Originally, their ball was held on Christmas night and then later moved to earlier in December. They were the first to introduce young ladies at so-called call-outs at the beginning of each ball.

It is written that, at one early ball, costumes for the members were not ordered in time for the ball and all that could be found in any number at costume rental stores were Santa Claus costumes. When the members showed as Ol' St. Nick, the press deemed them the Santa Claus Society, and

it stuck! However, the actual meaning of SCS is still a secret known only to the members.

Another non-parading mystic society founded in the late 1800s and still going strong today is the Order of Dragons, first called the MWR Society. It was formed by a group of thirteen men unhappy with their membership in other mystic societies. In October 1888, the name Order of Dragons was selected, and the organization had thirty-eight members by the time of its first ball on February 22, 1889.

A magnificent Order of Dragons Leading Man's costume, worn at the organization's 100th and 125th anniversary balls, may be seen today at the Mobile Carnival Museum. It was designed by museum curator Edward Ladd. Also featured at the museum is a commemorative painting commissioned for the 125th anniversary.

In 1872, it was suggested by a group of business leaders of the day, led by Thomas Cooper DeLeon, to form a Mobile Carnival Association to expand Carnival celebrations in town. This would include crowning an Emperor. Colonel Daniel Huger was chosen to rule over Carnival in 1872 as the first Emperor Felix I.

By 1875, the efforts of the Mobile Carnival Association had convinced the Alabama state legislature to declare Shrove Tuesday, Mardi Gras Day, a legal holiday in the city of Mobile, and the public was advised "to close its doors against a Yankee female called business." The goal of the Mobile Carnival Association, then and now, was to promote Carnival season festivities as family fun for citizens as well as the thousands of visitors who travel to Mobile each year for the country's second-largest community festival.

From 1881 until 1898, the Mobile Carnival Association had some ups and downs and almost fell out of existence. However, it was re-formed in 1898 as the Second Mobile Carnival Association, and Emperor Felix (Felix is Latin for "Happy" or "Lucky") became Felix II. The Second Carnival Association was led by Adrian B. Dure as president. He was intent on bringing at least two days of entertainment to town on Lundi (Monday) Gras as well as Mardi (Tuesday) Gras. An orchestra was brought from St. Louis to give concerts in Bienville Square, the oldest public square in downtown Mobile, and at Dumas Place on Government Street. Fireworks were displayed both night and day. Prizes were offered for costumes and dances. Boat races were held. The streets were decorated and brilliantly lighted at night.

Today, and since 1927 when the Mobile Carnival Association reorganized a third time, the MCA King is known as Felix III. An Empress would not be crowned until 1894. The first Empress was Ethel Hodgson. The Emperor was

no longer a "celibate" ruler. Both Emperor and Empress would soon become "King and Queen." Though prominent middle-aged men and women were originally the Kings and Queens of Carnival, soon young men and women in their early twenties, sons and daughters of prominent Mobilians, assumed these roles. The parents and their families became responsible for the young royals' expenses. "Courts" were added later, consisting of young ladies and gentlemen of similar age, numbering as many as twenty-four of each as "Ladies" and "Knights." Still another court for young teenagers would bring a King, Queen, Knights and Maidens.

Equerries, Heralds and Pages, consisting of five- and six-year-old boys were added early on. These young men have specific jobs at the royal coronation of the Queen. Equerries carry the crown and scepter of the Queen for the King. They carry these on pillows to the King's side as they make their way to the thrones where the King will soon crown his Queen with her crown and present her with her scepter. Heralds pretend to blow the horns at the musical introduction of the coronation. The Pages are flanking the King's and Queen's trains, making sure they flow correctly along the coronation procession to the thrones.

The Mobile Carnival Association's emblem is a crowned mask on a banner that reads "Felix 1872." The banner sits on a shield that shows the flags of the six nations that have ruled over Mobile, all on top of a scroll reading "*Carpe Diem*," or "Seize the Day."

It was during the same time period of the founding of the Mobile Carnival Association that one of the country's oldest men's clubs was founded, and it has played a significant role in Carnival celebrations to this day. The Athelstan Club was founded in 1873. Originally a Masonic order consisting of some of Mobile's most prominent men as members, the group decided to turn itself into an exclusive men's club with a limited membership of one hundred. It was said that the Masonic rule against alcohol may have contributed to the decision to form an independent group. James Fleetwood Foster was chosen as the first president of the club.

Many of the club members were also members of the Mobile Carnival Association and had children who were chosen Kings, Queens, Ladies and Knights. The club would provide spaces for parties and balls and even private stands in front of its building on the parade route for members and guests to watch parades. Over the years, the Athelstan Club has been a social gathering space for the royalty of Mobile, as well as their family and friends.

Also during the late 1800s, Mobile saw the first minority participation in Carnival. It was an indication that Carnival celebrations were moving

beyond the Catholic and Anglican majority. The first Jewish society, the Continental Mystic Crew, was founded in 1891, and it hosted balls until 1913. Two other Jewish mystic societies followed in the 1900s, but both were short-lived.

Order of Doves was the first African American mystic society. Founded in 1890, its first ball was in 1894, and the society had continuous balls until 1897. Not long after, the African American community greatly expanded its participation in the Carnival season.

Toward the end of the nineteenth century, while the nation prospered on the heels of the Industrial Revolution, Carnival season celebrations, balls and parades reached a fever pitch that would not be seen again until the late twentieth century.

As detailed above, a few of the original mystic societies remain with us today. However, there were as many as thirty-five parading societies and thirty-eight non-parading societies during this festive time. The most popular places to hold the elaborate balls were Temperence Hall, Armory Hall, the Princess Theatre and hotel ballrooms. Most of these societies held parades and/or balls for only one to five years and then vanished.

The following is a list of parading organizations formed after the Civil War that failed to continue into the twentieth century and ball-only organizations that similarly did not make it beyond about 1900:

PARADING ORGANIZATIONS

Lost Cause Minstrels
WAW
SSR of P
Gum Drop Rangers
Knights of Cosmos
MCS
DKS
LPO
QOP
Merry Crowd of Bachelors
Red-Eye Club
SRT
RAR Society
HKD Band
MJ Minstrels

Eight Solid Men
Mardi Gras Pilgrims
IMC (Cock of the Walk)
HWA
Children of Momus
The Rising Generation
HWL
Whistler Independents
MMK Band
HLB Club
OYM Club
ASM
OOF
Three Mile Creek Boys
ALC

UPR
Order of the Moon
Mystic Krewe of Mirth

Order of Druids
Krewe of Cyreniacs

NON-PARADING

DD
MWM
Continental Mystic Crew
TNC
Order of Imps
MYM
Mid-Winter Revelers
Krewe of Mahomet
POP
Order of Doves
Order of Lurks
Knights of Pleasure
Knights of Pegasus
Spirits of the Night
YMFS
MMF
Aunt Dinah
KOB
Leap Year Domino Club

Knights of Glory
Imperial Funmakers
Sons of Saturn
Disciples of Terpsichore
Merry Midnight Maskers
Knights of Terpsichore
MGC
SOM
Order of Orioles
Pink Domino Society
Easter Mystic Revelers
CDC
Merry Easter Mystics
Knights of Dreamland
Lovers of Mirth
SEC
Order of Maskers
Young Men's Clown Club
Phifty Phunny Phellows

It seemed that in a town of only thirty thousand (15 percent of the population of modern Mobile), every little group of friends formed some sort of mystic society, however short-lived, with balls, processions or parades. That participation created a community festival matched only by our sister city to the west, New Orleans.

Night becomes one shimmering glow of vari-colored lights through which the mystic orders roll their brilliant pageantry towards their opera houses where their masked balls are held.
—*T.C. de Leon, 1890*

Pre-World War II Mardi Gras

The event most asked about on the Timeline Wall in the main hall of the Mobile Carnival Museum is: "1902: Masks are prohibited from public use." Perhaps it is asked about so much because it is at eye level on the wall, or perhaps it is a really odd thing to be banned, but there is a good reason for the restriction. Unknown to most of us today, historians reflect on the early 1900s as a time when crime was as bad as it has ever been in America, and at that time, criminals were known for wearing masks—hence the term "masked bandit."

At that time, the public often dressed in costumes with masks during Carnival, just as the maskers did on floats. Local authorities were concerned criminals dressed up with masks could take advantage of the situation in downtown Mobile. Wintzell's Oyster House Restaurant dates from 1938, but the building, the oldest wood-frame commercial building in the Lower Dauphin Street Historic District M, was built in 1892 and named New Era Saloon to bring in the new century. Saloons were so popular into the early 1900s that women became upset with their "menfolk" going out every night and getting "sloshed," and it led to the temperance movement and eventually Prohibition.

It was during the time of Prohibition that entry cards were introduced in Mardi Gras ball invitations. When many balls were held in hotels, such as the Battle House and Cawthon Hotels, tickets allowed your host, the member who invited you, to give you his room number so you could visit him for a little "refreshment." Today, these entry cards allow you entry into the balls.

Other than those of the older established parading organizations, such as Order of Myths, Infant Mystics, Knights of Revelry and Comic Cowboys, there were suddenly far fewer parades than in the late 1800s, when it seemed every Tom, Dick and Harry formed a parading society, however short-lived. The only recorded parading society formed between 1900 and World War I was the Followers of Apollo, which paraded in 1911 and 1912. However, there were sixty-two ball-only mystic societies formed between 1900 and the end of the First World War, most of which were also short-lived.

1900	Spirits of Darkness
1901	Yellow Dominos
1901	Fifty Foolish Females
1901–05	Late Easter Rabbits
1902	Merry Maskers Social Club
1903	LOT
1904–07	Knights of Joy
1904	Knights of Folly
1904–10	Monday Evening Maskers
1905–06	Krewe of Terpsi Chore
1905	OOG
1905	Merry Dancing Club
1905	Merry Maids of Mirth
1905–06	Order of Rex
1905	PDQ
1905	OOJ
1905	SOC
1906	EOI
1906	KKK
1906	LOF
1908–13	Merry Maskers
1908	Merry Mystic Krew
1908	MMOT
1909–?	Las Des Conocidas "The Fair Unknown"
1909	GOM
1910	Carnival Flirts
1910–11	Kickshaw Society
1910–14	Frolicking French Maidens
1910–14	Merry Mystic Maidens"
1910	RRHM
1910	Merry Mardi Gras Maskers

1911–12	Flowers from Fairlyland
1911–12	Merry Maids of Mirth
1911–12	Followers of Apollo
1911–13	The Mysteries
1912–14	FOF
1912–13	Mysterious Thanksgiving Maskers
1912–13	Knights of the Prison
1912	Jolly Masqueraders
1912	JCM
1912	OOCC
1912	Merry Carnival Maids
1913	Merry Mystic Trailers
1913–14	Followers of Felix
1913	Knights of Prisoners
1913	Dairy Maids
1913–14	The Quaker Maids
1913–14	MCM
1914–16	RBM
1914	Knights of Comus
1914	Original Utopia Club
1915	Merry Carnival Maids
1915	BFB
1915–17	Blue Birds (Jewish)
1915	Merry Carnival Maskers
1915–2?	The Mystics (Jewish)
1915	Jolly February Maskers
1915	New Year's Maids
1916	New Year's Maskers
1916	The Leap Year's Dancers
1917–19	Fifteen Funny Fellows
1917	HCD

As participation in the Royal Courts continued to grow in the decades prior to World War II, the royal costumes also grew in size and extravagance. Kathryn Taylor deCelle wrote a lovely description of the Queen's attire in *Queens of Mobile Mardi Gras, She Walks in Beauty*. The following is from her writings entitled "Production of a Queen's Train 1903–1973":

> *The Queens' wardrobe has always been of great interest to her friends and subjects alike as she appears before the public at many functions during her brief reign. As a debutante her ensembles are many and very lovely, but*

those she wears through the Mardi Gras weekend are carefully planned and coordinated because they are scrutinized by the populace.

It is traditional for the Queen to wear, in addition to a lovely gown, a robe or mantle, better known as a "train," with a high standing Medici type collar of lace and jewels. This costume is seen for the first time at her coronation, now held on Saturday night. A great deal of secrecy is attached to its production.

Apparently some of the early Queens did not wear trains as we know them in the 20th Century. In searching for information as to the origin of their production we find that Mrs. Fanny Elsworth was one of the first ladies to produce a Queens's train, one for Miss Venetia Danner in 1903.

Subsequently Mrs. Elsworth made trains for Miss Gertrude Smith in 1904, Miss Nancy Clark in 1905, Miss Aline St. John 1906, Miss Helen Buck Taylor 1911, Miss Lucy Leatherbury 1912, Miss Mabel Hartwell 1915. Miss Katherine Van Antwerp 1921, and Miss Eran Izard 1924. Except for Miss Danner, who did not wear a collar, Mrs. J.S. Hale, Sr. (Ocie), Mrs. Elsworth's niece, made collars for these Queens.

In 1928, Mrs. Hale, assisted by her mother, Mrs. O.F. Elsworth, made a train for Miss Helen Rogers. Miss Rogers' train was designed by her father, Mr. George Rogers, the prominent architect, who for many years directed the annual coronation.

From 1928 until 1949, Mrs. Hale produced nine beautiful, original trains, with collars for the following Queens: Miss Rogers 1928, Miss Isabelle Bush 1932, Miss Grace Bestor 1933, Miss Emily Staples 1934, Miss Margaret Lyons 1935, Miss Mary Bacon 1936, Miss Cornelia McDuffie 1937, Miss Tallulah Dunlap 1941, and Miss Gertrude Atkinson 1949.

Mrs. Hale's talent is indeed unique. Her workmanship has been emulated by professionals and amateurs alike through the years. Her designs were all original, planned in secret with the Queen's family. The fabric was usually heavy white satin with a lining in a color selected by the Queen, with jewels appropriate to the design. Mrs. Hale often went to New York to purchase her jewels and imported fabrics. She preferred German pearls to the French which were available in that period. Jewels were all sewn by hand, using number one hundred thread waxed for strength. Her trains were a standard six yards long and two yards wide, tapering to shoulder width. Mrs. Hale required three months, working alone, to complete a train. No one except members of the Queen's family saw the train until the night of the coronation.

Mrs. Hale's husband, Mr. Julian Hale, Sr., assisted his wife in many ways in the production of her masterpieces. Not the least was his help with the beautiful collar frames, shaping and fastening wires in a particular way to insure their upright position. On the night of the coronation Mr. Hale took the train, in a specially constructed box, directly to the wharf where the production took place. Mrs. Hale then put the train on the Queen who was already dressed in her coronation gown.

In the years prior to World War II, when the coronation was held on Monday night at the Municipal Wharf under cover, but with a limited seating capacity, the Queen's robes would be displayed in a department store window during the week following Mardi Gras, giving all the Queen's subjects an opportunity to view the lovely garments.

The late Mr. George Jumonville, Sr., a noted Mobile dress designer, made many beautiful coronation gowns and trains for Ladies of the Court and for the following Queens: Miss Marie Courtney 1922, Miss Dorothy Turner 1926, Miss Dorothy Tonsmeire 1927, and Miss Reba Lyons 1940.

Continuing from the post–Civil War era were two ball-only men's mystic societies—the SCS and Order of Dragons. Two ladies' organizations were formed prior to World War I and continue to have balls today. The Spinsters were formed on October 20, 1910. Ellen MacMahon was their first president. A parrot was chosen as their emblem. Their first ball in 1911 featured members dressed in Turkish harem attire. One of the unique features of the Spinsters is that every year on Valentine's Day, they chose a Bachelor of the Year, an honor coveted by Mobile's most eligible bachelors.

Not long after the Spinsters was formed, another group of women formed the Sirens in 1914. These were sixty-five of Mobile's most prominent married ladies who later increased their membership to one hundred. It is said they used the Order of Myths' constitution as an example for creating their own. Their first ball, at the Battle House Hotel, was in 1915. Emily Hearin described the history of the mythological Sirens in her book *Let the Good Times Roll*, writing, "In Greek mythology the Sirens were known as enchantresses of the sea. They lived upon a rocky island and sang with irresistible sweetness. Passing sailors were spellbound by the Sirens' voices and wrecked their ships upon the islands bleak shore."

George Rogers, prominent architect of the era, gave his time and talent to help the Sirens with designing the scenery and decorating the ballroom for their first ball.

During the period prior to World War I, a time when Mobile had a red-light district, the ladies of the evening were known to have a little Mardi Gras fun of their own. The following story by George Schroeter is from Hearin's *Let the Good Times Roll* and was originally published on February 3, 1985, in the *Mobile Press-Register*, in which the author writes about the "occasion when all the hookers came to a Mardi Gras Ball":

> *It is sometimes forgotten that, although Mobile had many late-Victorian attitudes, we did have a red light district. Ordered by Section 363 of the 1897 City Code and called "Houses of Ill Fame" this ordinance set the limits of what was called "the district." It permitted no houses of prostitution outside an area bounded by St. Michael from Lawrence to Warren Streets, over to St. Louis and up to Cedar. Forming an L shape on the map, it was intended to make the best of a bad situation by limiting and containing it...*
>
> *At this first public carnival ball, held February 4, 1913, the district turned out in force. The account made page one the next morning. The girls came, some in the same night-hawk cabs that usually brought the customers to them, others in automobiles painted and jeweled and gowned for the time of their lives. And they had it.*
>
> *The reception committee for the public ball was an impressive list of names, including John T. Cochrane, George B. Rogers, Orville F. Cawthon, Frank T. Parker, Ben H. Harris, and Paul Wilson, among others. The ball's purpose was to give everyone not included in the OOM ball a way to conclude Mardi Gras.*
>
> *Mayor Leon Schwarz and Police Chief Crenshaw saw that it was an orderly ball. In fact, the mayor made the only arrest...A fight broke out among onlookers, the mayor was cursed by some of the rougher men and at the very height of it all, several automobiles arrived containing "prominent society women and their husbands." They had come from the O.O.M. ball to see how the public ball was going. They certainly found out.*
>
> *The rest of the evening was something of an anti-climax [sic]. Girls from the district danced the Turkey Trot and the Bunny Hug, both of which were just coming into prominence at the time. About 1,000 people attended the ball, and when it was over, a good time had been had by all.*

Between the First and Second World Wars, our country witnessed the Roaring Twenties and the Great Depression. Only a few parading and ball-only mystic societies, as well as the Mobile Carnival Association's Royal Court, survived the First World War.

The Order of Myths, Infant Mystics, Knights of Revelry and Comic Cowboy's, all from the 1800s, continued to parade, and the ball-only societies to survive were the Strikers, SCS, Spinsters and Sirens.

The Roaring Twenties produced three great organizations that are still with us today. Two of them were ladies' societies.

Founded in 1920, the Follies held their first ball in December 1921. In her book *Let the Good Times Roll*, Hearin describes beautifully the first ball of this ladies mystic society:

The ball took place amidst a setting of such beauty it rivaled the fabled Garden of Hesperides. Three sisters, the three nymphs, daughters of Hesperus, who together with the dragon Ladon, guarded the golden apples which Hera, the Greek Juno, had received as a wedding gift. Human folly is as old as the world itself. Each age has its own brand of folly, but the brand of folly of this new organization, now one of Mobile's oldest mystic societies, was harmless and it was created to bring pleasure and happiness to the members, their partners, and their friends.

The auditorium was decorated into a bower of roses, with lighted trellises covered with smilax. The stage was arranged to resemble as much as possible the Greek garden of Hesperides where the dragon lurked but also stood guard over the fabled garden. This dragon was seen on top of a huge gold vase which occupied one side of the stage. The dragon opened his mouth and out emerged a beautiful butterfly—not a real butterfly, of course, but little Emily Hearin Staples in a golden costume complete with the freedom and grace of a happy butterfly to the dreamy music of "Golden Butterfly." (The author says to herself and to the reader: "It must have been awful!") After her dance she returned to the stage, waved her magic wand to summon from the garden all the Follies members who were playing amidst the Grecian columns and around the fountain.

Then two fairy spirits, little Grace Tarleton Bestor and little Margaret Wiley Lyons, dressed in their miniature Follies costumes, appeared with jingling bells making music with their every movement. As soft chimes were heard in the distance, the Follies members, obedient to the wave of the golden butterfly's wand, emerged from the stage. They marched the length of the ballroom led by the two fairy spirits and sought their partners who were eagerly awaiting their arrival. Meanwhile, the butterfly and the two miniature Follies made a pretty tableau posing on the stage beside the fountain. (It must have been a blessing when their proud parents took them home.)

The leader of the ball, whose identity is never revealed, chose Martin Horst to lead the dance with her. As members of the Follies with their partners made a grand circle of the ballroom, the light shed from the roses and smilax in the columns made the ballroom a scene of beauty. A red and green curtain was used to separate the garden where the call-out gentlemen awaited the first dance from the seats arranged at the rear of the hall. A large crowd of guests had come to see and enjoy the first Follies ball. Souvenirs of the evening were tie clasps enameled in the Follies colors of red, blue and green and watch fobs engraved with the Follies mask.

The general chairman of the ball and chairman of the reception committee was Mrs. Greenwood Ligon, who, with her charm of manner and poise, welcomed the guest, introduced the mystic ladies, and told the story of the Follies, which comes from Greek mythology. The usual announcements were made. The first two dances were reserved for the maskers, after which the dancing would be general, and, as was the custom, it was ladies rush all evening (with the ladies having the privilege of choosing their dance partners) since the Follies was a ladies mystic ball.

The 80 charming Mobile matrons were showered with compliments and congratulations because they had achieved such success with their first anniversary ball and they had added one more mystic society to Mobile's social life.

Mrs. Hearin, who as a child portrayed the butterfly in the first ball, later became Queen of the Mobile Carnival Association in 1934, with many of her descendants participating in the Royal Courts. After all, she was married to three prominent Mobilians with whom she had a number of children.

The Roaring Twenties brought Mobile one of the largest and most loved parades and balls with us today and the only parading society founded in the 1920s. This men's society was organized in 1921. It was first open only to Knights of Columbus members, but within a few years, membership was open to others. In the beginning, the name was Krewe of Columbus and then changed to Crewe of Columbus with a reorganization of the society in 1937. A few Mobile societies use the word "krewe" in their names. The only use of "crewe" occurs with Crewe of Columbus.

The society's first parade had twelve floats (though its parades today have about twenty), and one Mobile newspaper claimed it was "one of the most gorgeously decorated parades ever staged." The first few floats, which are called Emblem floats, are permanent and appear year after year. Following are the Theme floats, which reflect something about the ball theme, which

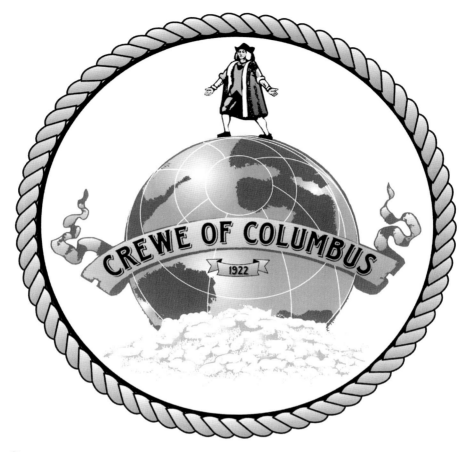

Crewe of Columbus emblem logo. *Rich Gudmundson collection.*

changes each year and is different for each mystic society. The Crewe of Columbus Emblem floats reflected, as they do to this day, America's history embracing Christopher Columbus.

On the first float was—and still is today—a masker portraying Christopher Columbus on top of a giant revolving globe of the world. The second float showed Columbus explaining to the scholars of his day his revolutionary idea that the world was round, not flat. Following was a float depicting his visit to Queen Isabella of Spain, asking for her monetary help in sailing to the "New World." Others followed depicting his voyage to the Americas. Three of these included beautiful floats depicting Columbus's three ships: the *Nina*, the *Pinta* and the *Santa Maria*.

In 1941, the Crewe of Columbus was the first to begin pulling its floats with tractors instead of mules. The Crewe members had no parades during World War II, and in the first parade after the war in 1946, they added members dressed as Indian chiefs in full headdress of four American Indian tribes flanking Columbus on the first float. In later years, they increased the number of Indian chiefs to six.

Through the 1920s, the Crewe was the only mystic society whose members built their own floats, with professionals adding only paint, gold leaf and glitter. The Crewe of Columbus was also the only mystic society that continued the tradition of announcing each lady's name for the first dance, until the end of the twentieth century. Another of its traditions, lasting until the end of the twentieth century, was parading in procession in costume before their evening parade through Mobile's largest mall.

In 1927, the Fifty Funny Fellows (FFF) was organized. This society of men actually succeeded two other Funny Fellows societies. Five Funny Fellows and Fifteen Funny Fellows had organized prior to the present Fifty Funny Fellows society, which remains with us today. Its membership is actually larger than fifty, but in order to be consistent with its name, the group added categories of members. There are fifty members, but also there are fifty associate (younger) members, fifty Emblem (older) members and perhaps more. These men chose a jester as their emblem (mascot). A jester is a comedian whose job it is to entertain the court. This is different from a folly, who leads the OOM's parade and the KOR's parade on Mardi Gras Day. A folly is a silly notion or character of the mind that performs silly or frivolous comedic acts.

The Fifty Funny Fellows Ball has always been considered quite exclusive because it is by invitation only. The cost of the ball is the sole responsibility of members. This is also true of several of the older mystic society balls.

The FFF selects a Queen of the society each year, as do many of the men's societies, and hold a reception for her on the Sunday prior to the Wednesday night ball (always the Wednesday prior to Mardi Gras Day). Some say this reception is a more elaborate affair than the ball.

In 1928, the Mobile Carnival Association started the Children's Flower Parade (later changed to the Floral Parade). This parade was Carnival's longest. Mr. Sidney Simon was asked to plan and arrange this colorful event. By then, the president of the MCA felt it was necessary to promote a family Saturday event to keep people downtown. At the time, there were no weekend parades preceding Fat Tuesday. The Floral Parade was the first.

The MCA Juvenile Court members are selected by an MCA committee and ride in the first floats of the Floral Parade, followed by floats representing

different themes each year filled with selected children from various schools and organizations. It is the only full parade to now appear twice in Carnival season, once on Saturday afternoon and again on Monday at noon following the King's Parade. Later in the twentieth century, other children's parades were introduced as neighborhood Carnival events.

Although the country and Mobile suffered during the Great Depression, Mobile's population grew over 15 percent from just over sixty-eight thousand to almost seventy-nine thousand by 1940, and Carnival season continued and grew adding a parading society and two non-parading societies, all with us today.

Here in "Old Mobile," members of the Junior League (a well-heeled group of young ladies who do many charitable works) may, after retiring from the group, become "sustainers." However, Mobile has yet another advanced age category for the ladies beyond sustainers called "Betty Bienvilles."

Bienville was the founder of Mobile in 1702, and in 1936, his descendant, Ms. Betty Bienville, social editor of the *Mobile Press-Register*, wrote the following about the new ladies organization, the Thalians:

> *"That life begins at forty" will hardly have any effect on those desiring membership in a new ladies mystic organization which has just been formed. The edict has gone forth if you are past 35 you are not eligible. Rumor has it that for the last few weeks some busy ladies of the younger married set have been getting together forming this organization and the plans are now underway for their first ball. I have heard that they have already set the date for the first dance which will be given on the Tuesday that precedes Thanksgiving in November 1937.*
>
> *The young mystic matrons are calling themselves the Thalians. The name comes from the work of Thalia, who was the goddess of mirth and merriment. Those who have glanced at sign boards and posters adorning the walls of a theatre will remember seeing two masks ofttimes set together. One mouth expresses tragedy in rather serious aspect while the other smiling mouth represents comedy. The goddess Thalia is to be the emblem of the Thalians. This will be the first mystic ball of the season which is still about eight months in the future. The membership has every reason to believe that the organization has been well-planned and that their first ball will be a success.*

Thalia is the Greek muse of comedy and pastoral poetry and is one of the Three Graces. Translated from Greek, Thalia means "the blooming one." The society's beautiful balls continue to this day.

In 1938, five ladies met at the Country Club of Mobile and formed the Nereides mystic society. Nereides, which they chose for their emblem, were mythological sea nymphs. These mermaids were the daughters of Nerus, a sea god. They had the gift of prophecy and the power to assume different shapes. The society's emblem shows a Nereide riding a great sea monster over the ocean. The group's first ball was held January 19, 1940, at the Battle House Hotel. To this day, the balls are considered one of Carnival's most tasteful, and attendance is kept to a limited number.

Another group consisting of married ladies formed one year before the start of World War II. They called themselves Order of Juno and organized in December 1940. In Roman mythology, Juno was the wife of Jupiter, king of the gods. She was the queen of Mount Olympus. The peacock was sacred to Juno and was selected as the emblem of the organization.

In Hearin's *Let the Good Times Roll*, a poem written in 1941 tells the story of the Order of Juno:

> In the year of 1941
> A group of Matrons
> Joined together to be as one.
> Not only for fun, but to help our nation
> And up to now it has our ovation.
> This society is called the Order of JUNO,
> Juno being the goddess of marriage.
> Each member proved their worth
> By uniting and coming through.
> But just as well we know,
> An honor indeed to be called a Juno,
> In years to come, may Juno still survive.
> Let us keep her alive;
> In doing so we keep our own lives alive,
> For is not Juno our goddess of matrimony?

The Mystic Stripers were officially organized on January 10, 1940. It was a ball-only men's mystic society until 1948, when the group members held their first parade prior to their ball. They struggled to hold together during World War II because so many of their young members went to war.

It was float builder Joseph Andrade, designer of sets for the Stripers' balls, who suggested the Stripers use the tiger and the zebra, both having stripes, as their mascots. Mr. Andrade designed the group's floats until 1950, when

the job was handed over to George Ciminale. Twenty-nine years later, in 1979, it was granted to Steve Mussell.

The Stripers introduced plastic cup throws, one of the most popular "catches" of Carnival season. Their parades in the latter part of the twentieth century included such crowd-pleasing sights as the Budweiser Clydesdales, and their ball featured well-known entertainers like the Lawrence Welk and Guy Lombardo Orchestras, the Temptations and Vince Vance and the Valiants.

The African American Carnival community came into its own during the Great Depression. Members had organized the Order of Doves in 1890 and had balls from 1894 to 1914. According to *Mardi Gras in Mobile*, published by the Mobile Area Mardi Gras Association, "Miss Florina Nicholas, attired in pink silk with satin stripes, was acknowledged the 'belle of the ball'" during this period.

When the Order of Doves went out of existence in 1914, the Original Utopia Club was organized, followed by the Midnight Mystics and the Suavettes Social Club, a ladies' society.

Before long, another African American society was formed by a prominent African American Mobilian, A.S. May. It was called the Knights of the May Zulu. Some say the name comes from his appreciation of the African American mystic society Zulu of New Orleans, which, to this day, names a King and Queen at Mardi Gras who rule as New Orleans' African American royalty for the following year.

Mr. May and his Knights of the May Zulu were the originators of the first parade of the African American community in Mobile. They paraded on Davis Avenue, the retail heart of their community at the time, and did so until 1952.

A ladies' society called the Smart and Thrifty Ladies Social Club and another new men's African American organization calling itself the Strikers Social Club (not to be confused with the 1842 Strikers) produced a parade in 1939 along Davis Avenue. Also chosen were a King and Queen, as well as Knights of the King and attendants to the Queen. The King was Winston A. Allen, and the Queen was Ruby Morgan. This short-lived African American court lasted one year. The African-American Royal Court that exists today was founded the following year, in 1940.

The African American community's Carnival activities were growing in number and expanding during the Great Depression. Also during this time, the Colored Carnival Association was founded in 1938 by Dr. William L. Russell, Samuel Bestreda, J.T. McKinnis and Dr. James Franklin. The name was changed in 1971 to the Mobile Area Mardi Gras Association

(MAMGA). Dr. Russell was president of the association for fifty years, and there have been only six presidents since.

The first parade was in 1940. The Carnival association would also produce a mayor of Carnival as well as a Royal Court. The mayor would be elected by community vote and would have several Carnival-related duties, including presenting the key to the city to the King. The first mayor was Samuel Besteda. Later, in the 1970s, the elected position of mayor would be changed to a selected Grand Marshal.

It was Fredrica Glover-Evans who is credited with starting the Royal Courts of the Colored Carnival Association. It is she who suggested King Alexis I as the name of their King (a play on Alex, name of the first selected King). Known as the "Mother of Colored Carnival," Glover-Evans worked with the Royal Coronations until 1967. She had the honor of being appointed to the National Youth Administration by President Franklin D. Roosevelt.

It was said that being chosen King or Queen by the association was an honor that "no amount of money could purchase" according to Dr. William Russell, president of the organization. "The deeds of community service and family prestige" would determine the Royal Courts, he said.

The first King of "Colored Carnival" in 1940 was Alexander Herman, father of Elexis, who was Queen in 1974. Elexis Herman was later chosen by President William J. Clinton to be Secretary of Labor in 1992. The first Queen was Aline Jenkins. There were five Ladies of the Court who were chosen earlier as the debutantes of the Utopia Social Club, and there were five Knights, escorts of the debutantes. Later, as with the Mobile Carnival Association, the number of Ladies and Knights of the Court grew in number to as many as twenty-four of each.

By the time of World War II, several African American mystic societies had come and gone. They included the Order of Doves and Knights of May Zulu Club, two gentlemen's societies, and Suavettes Social Club and Emeralds Social Club, both ladies' societies.

During the prewar era, African American parades were held in their communities, the most prominent being the Davis Avenue area. It would not be until the 1990s that the Mobile Area Mardi Gras Association's huge thirty-two-float parade, the Mammoth Parade, would roll on Mobile's famous Government Street, the "main street" of the city.

The Mobile Carnival Museum has several items on display from the pre–World War II period. A First Lady's train from 1936 is displayed in an upstairs gallery and reflects a look of restrained opulence in its simple yet elegant art deco design. Next to it, in a glass-covered display case, is a

Juvenile Queen's train from the early 1920s. In the second-floor hallway is a Herald's costume worn by Jack Stallworth as a child in 1930.

Also upstairs in the museum is a film of two parades in color from 1939 featuring the Order of Myths and the Infant Mystics. This footage represents an amazing feat because the first major motion pictures in color were made in 1939: *Gone with the Wind* and *The Wizard of Oz*.

Carnival festivities were postponed during World War II out of respect for the millions of young men and women who fought in that conflict. At the same time, with naval fleet construction and shipping interests, Mobile's population jumped by 64 percent. By the time of the 1950 census, it had grown to 129,000 and again by 57 percent to 203,000 by 1960. These were the largest increases since the decades prior to the Civil War. Since 1960, while Mobile's city population has remained at about 200,000, Mobile County's population has reached nearly 500,000.

Chapter 5
Post–World War II Mardi Gras

Mardi Gras is very old, but it is also very young, it belongs to the past, yet also to the present and to the future…It will exist in other forms, in other times, in other places. It would be wonderful if the clown in the grinning mask should appear on all the Main Streets of the world, if the blazing flambeaux and the rocking floats were everywhere, if everywhere there could be a season or at least a day devoted to laughter.
—*Robert Tallant, 1947*

The latter part of the twentieth century brought big changes to Mobile and its Carnival season. The period also brought great changes to the country and the city—socially, racially and economically. While World War II brought great economic and population growth, the 1970s brought the opposite, as Brookley Air Force Base closed, taking with it twenty-five thousand jobs, and malls and suburban shopping centers emptied, leaving downtown Mobile in a state of abandonment.

As the late 1980s and '90s rolled around, Mobile's city government became more inclusive, and the baby boomers began the great restoration of Mobile's old residential neighborhoods, which, by the twenty-first century, included seven historic districts covering six hundred square blocks, with six thousand buildings and homes listed on the National Register. The downtown retail area of Old Mobile was transformed from a ghost town into a showplace of eateries, art galleries and nightclubs. By the end of the twentieth century, over 250,000 people would pour into downtown Mobile to celebrate Mardi Gras Day.

Immediately following World War II, a beloved African American mystic society was born. The Comrades Social Club, originally a group of men called the Big Ten, was founded in 1946 and is still active today. Their ball is known for its "second line" parade dance. Second line is a tradition of brass band parades. Usually associated with New Orleans, the "main line" or "first line" is the main section of the parade, with members of the actual club who received the parading permit, as well as the brass band. Those who follow the band just to enjoy the music are called the "second line." The second line style of traditional dance, a jig of sorts, in which participants twirl a parasol or handkerchief in the air, is called "second lining." The great music, colorful dress and fanciful parasols have made invitations to this ball a first on many Mobilians' ball lists. Upstairs at the Mobile Carnival Museum is a great display of second line parasols made by Gloria Good, a prominent Mobile costume designer, and a running video of a recent Comrades' Ball.

Another African American society, the Crew of Elks, was founded in 1947. The Avignon Club, also formed in 1947, was named after the French town of the same name, which was the seat of the Papacy in the 1400s.

The Pierrettes, a ladies mystic society was founded in 1947 as well. The group's first ball was held in 1948 at Fort Whiting Auditorium. Its emblem is, of course, a pierrette. The name comes from the character in French pantomime dressed in a floppy white outfit. The ball opened each year with the emblem figure standing on a dais, after which she progresses around the ballroom floor to the strains of "Dance, Ballerina, Dance."

BRING ON THE DRAGONS! Chartered in 1948, the Mystics of Time (MOT) produce perhaps the most popular parade of Carnival—the dragon parade—which precedes the group's popular and well-attended ball. This organization is credited with bringing parade extravagance to a new level. A Mystics of Time historian explains in Emily Hearin's *Let the Good Times Roll*:

If you were to ask a child in Mobile who is familiar with Mardi Gras, "Which is your favorite of all Mardi Gras parades?" the answer would most likely be "The Saturday night parade," or "the M.O.T. parade," or "the parade with the dragons!" Regardless of the phraseology, nine out of ten would indicate their favorite as the parade produced by the Mystics of Time.

This ascension to the position of most popular parading organization by one of the youngest men's parading societies is not something that just happened. It is the result of many years of dedicated service by the present and past members who have worked with one goal in mind—to produce and

sponsor for the people of Mobile and the surrounding communities the very best Mardi Gras parade possible.

The group's emblem, as reflected on its Emblem float, is a depiction of Father Time embracing a clock with Roman numerals while holding a sickle. After the emblem float appears Vernadean, the dragon, as the first "mascot float," followed by her dragon children, Verna and Dean. The title float, which introduces a new parade and ball theme each year, follows.

The Mystics of Time was the first to introduce a sectional fire-breathing dragon to the Mobile parade scene; first to use fluorescent lighting as a major lighting source; and first to throw ice cream, azaleas and monogrammed rubber balls from its floats. The ball has brought in such national musicians as the Glenn Miller Band and Jimmy Dorsey's Band, along with local favorites such as Bill Lagman and Bob Schultz big bands.

Over the next two years, four female organizations were formed that are still with us today, two of them parading. The Dominoes Mystic Society was organized by Amelia Edgar (Mrs. Ernest Edgar Jr.) in 1949 to be made up of a membership of one hundred young matrons. She wanted a post–Mardi Gras Carnival season ball to be held the first Saturday evening after Easter. Only the KOR had a post-season ball called the Easter Revel. Today, neither group has a post–Mardi Gras Day ball.

Unlike other Carnival season balls, the Dominoes Ball is held from 8:00 p.m. until midnight rather than 9:00 p.m. until 2:00 a.m. Men may wear white or black dinner jackets rather than tails, and there is no theme for the ball. An announcement is made at the beginning of each ball that there is to be double rush all night. Double rush dances are those that allow women, as well as men, to cut in. Most often, their balls are held at the Athelstan Club in downtown Mobile. Today, the Dominoes Ball is about a month before Mardi Gras Day.

La Luna Servante, also organized in 1949, is a women's mystic society whose members claim to be Moon Maidens, or Servants of the Moon. Martin Johnson, a locally well-known Social Security Administration spokesman and ball master of ceremonies, was made an honorary member of the ladies' organization.

Even though the Polka Dots were founded in 1949 and the Maids of Mirth (MOM) in 1950, both women's mystic societies held the first two women's parades in 1950. The Polka Dots preceded the Maids of Mirth by only one night during Carnival season of 1950. It has been written they chose Polka Dots as a name for no other reason than they liked the sound of it. The society grew quickly to be one of the largest of Carnival. It was

estimated that 119,000 people came out in anxious anticipation of the first women's parade in history, which is amazing when you realize there were only 129,000 living in Mobile at the time.

Every year, the Polka Dots have a member who is Queen of the ball and another who is Gypsy Queen, both appointed by the President who, as the first President did, may hold that office for decades. According to Hearin:

> *The traditional emblem float leads the parade, with the Gypsy Queen riding in a chariot drawn by three silver stallions. The stallions are the sons of Pegasus, the famed winged horse of the Muses, born of the sea foam and the blood of the slaughtered Medusa. He was caught by Bellerophon who mounted him and slew the fire-breathing monster Chimaera. When Bellerophon attempted to ascend to heaven he was thrown from the horse Pegasus and Pegasus mounted alone to the skies to become the constellation of that name. Pegasus, the winged steed, with a stroke of his hoof caused the Fountain of the Muses, Hippocrene, to well forth the soul inspiring waters of the fountain. The horse Pegasus has always been touted in song and story. He rose heavenward to Mount Helicon in Greece, the residence of Apollo and the Muses.*

The Maids of Mirth followed the Polka Dots one night later in 1950 with a memorable parade as described in the *Mobile Register* the next day:

> *"Cherchez les femmes."*
>
> *That was the advice given men and women alike prior to Tuesday night's Mardi Gras parade. And jammed sidewalks, streets, intersections and squares offered proof positive that that advice was taken.*
>
> *"Les femmes" they were told to "cherchez" were Maids of Mirth, making their public debut as a mystic society in the second street parade of the 1950 Mobile Carnival season—and, at the same time, making it two out of two parades stages by women.*
>
> *In a half dozen floats, the Maids related the story of "Mythical Maids"—a story ranging from the sacred virtues and religious crusading of Joan of Arc to Salome, winsome goddess of wine and song…*
>
> *Spearheading the lavish display of femininity Tuesday night came the M.O.M. emblem float, "The Spirit of Carnival." Emblazoned in the M.O.M. purple and gold, it sported three gaily clad emblem gals prancing among brilliantly colored balloons and occasionally letting a helium-filled sphere rise into the sky.*

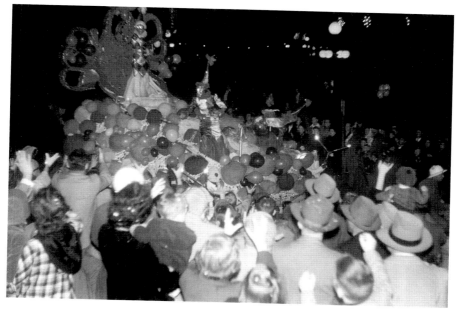

Maids of Mirth Emblem float, 1950. *Author's collection.*

The guiding hand behind the organizing of the MOM was Catherine Cook Haas, who designed many beautiful floats for the group's parade for many years. Cornelia McDuffie Turner was the first president. The shield for the Emblem float was designed by Marian Acker Macpherson, one of Mobile's best-known artists.

It is said that the husbands of the ladies of the Polka Dots and MOM were weary of the ladies attempting a parade as well as a ball, and some had the nerve to actually boycott their wives' first balls!

During the 1950s, four couples mystic societies were founded, three of which are still with us today. The Etruscans incorporated in 1950. Their name is derived from the Etruscan people, who were believed to be Italians far more advanced in culture than the Romans whom they preceded.

The Don Donas organized in 1953. The society is not of Latin American origin, but its emblem and theme song pay tribute to Mobile's Spanish heritage.

Also in 1953 came the Harlequins. They fashioned themselves after the Dominoes, except it was a society of couples instead of ladies. Like the Dominoes, their ball has no theme, lasts from 8:00 p.m. to 12:00 midnight and has a double rush all evening.

Mobile's winter weather is mild by most standards. We have many upper Midwesterners and Canadians who "winter" along our sunny shores. We do, however, have cold snaps, as in 1951, when the *Mobile Register* reported the following about the Mystic Stripers parade, themed "Epics in American History," the night before:

> *A half hundred hale and hearty Mystic Stripers Thursday night braved sub-freezing temperatures and brisk north winds to stage their fourth annual Mardi Gras street parade. Attendance at the parade was pathetic because Mobilians stayed home by the thousands because of the icy outside world. Police reported no trouble along the parade route...Bandsmen found music-making as difficult as drum majorettes did trying to keep warm. Many musical instruments were frozen in the 21-degree weather, and well-intended toots became ill-sounding bla-a-a-ts or hisses.*

Kicking off each Mardi Gras Day, then and now, is a women's parading group founded in 1954, the Order of Athena. These ladies begin their parade at 10:30 a.m. on Mardi Gras Day. Athena is the Greek goddess of war, science and the arts. The Emblem float features Athena in a great flowing red cape riding in a golden chariot pulled by a pair of green serpents billowing smoke. This parade is a favorite of all ages. In 2014, the group's daytime ball, following its parade, marked its sixtieth anniversary.

Then in 1956, one of the largest Mardi Gras societies in Mobile was founded. The Order of Incas has one of the longest parades and biggest balls of Carnival season. The first parade and ball were held in 1957. The ball was led by James B. Martin III and his wife, who was Queen of the ball.

The Incas are known for their authentic Inca costumes with great feathered headdresses in brilliant colors, reminding some of the Mummers of Philadelphia, Pennsylvania. It is quite a sight to see these men in full regalia coming down the street on their beautiful floats.

Mystic crews that were short-lived and founded in the 1950s were the Court of Isabella (1951–53), Mystic Belles (1953–59), Forty-Niners (1953–59), Daughters of Venus (1954–66), Order of Jesters (1954–65), Mardi Gras Heralds (1957–61) and Belles and Beaux (1958).

During the middle of the twentieth century, a parade was held on Monday before Fat Tuesday (Lundi Gras) in the African American community along Davis Avenue (now Dr. Martin Luther King Avenue) known as Northside. This parade was for schoolchildren. The schools chose their own royalty who participated in the parade. For some years, the parade included participation

by the popular Mollys. This group was known for dressing up in unusually funny costumes as they pranced along the avenue. Many folks today express how much they miss the Mollys, and one of the permanent floats of the Mobile Mardi Gras Association's Mammoth Parade is in their honor.

Historian Julian Lee Rayford wrote in 1962:

In the moment a float comes abreast of you and passes with a great burst of flaming torchlight, the bands blaring their brass horns, gold and blue and red flashing in the scintillation of gold leaf—and maskers on the float jigging in fancy costumes, while candy is thrown over the crowd like rain—in that moment you stand there raised into ecstasy, trying to comprehend all you can in a blur of joy gone almost as soon as it began.

Only three ball-only societies and two parading organizations were formed in the 1960s and '70s that remain with us today. Founded in 1960, the Athenian Social Club was founded as an African American ladies' organization. Then in 1961, Le Krewe de Bienville was founded by a group of Mobile gentlemen who wanted to find a way to let visitors take part in Mobile's Carnival celebration by attending a Mardi Gras ball. Like other Mobile mystic societies, Le Krewe de Bienville is a private Mardi Gras society, but its purpose was to allow a way for out-of-town visitors to be invited. "Temporary" one-night memberships were sold through travel agencies, hotels and by mail, yet each ball invitation had to come through members. Le Krewe de Bienville was also known for entertaining out-of-town groups and conventions at mini-balls with mini-tableaux featuring beautiful costumes to thrill the onlookers. As you may recall, a tableau is a staged theatrical introduction of mystic society members, often with elaborate sets, and which may even include pyrotechnic displays. To entertain the many visitors to Mobile at Le Krewe de Bienville balls, quite a few of the MCA royalty, MAMGA royalty or Kings and Queens of Mobile's various mystic societies make an entrance. Today, Le Krewe de Bienville has a parade late Sunday afternoon before Fat Tuesday and sells rider positions on floats as well as ball invitations, or tickets, as they are called, to out-of-towners. These tickets must be acquired through the organization.

The Mystic Maskers is a couples' society founded in 1964. This group does not have a tableau. Members and guests arrive in costume, and the King and Queen of their society are decided by best costume. After the King and Queen are announced, members remove their masks and mingle with their guests.

BALLS AS OF 1962

Athelstan Double Rush
Athenian Social Club
Christmas Bachelors*
Comrades Social Club
Crewe of Columbus
Daughters of Venus*
Dominoes
Don Donas
Dragons
Etruscans
Fifty Funny Fellows
Forty-Niners*
Infant Mystics (IM)
Jolly Jesters*
Kings Dansante (Kings Supper)
Knights of Revelry (KOR)
Krewe of Elks

La Luna Servante
Maids of Mirth (MOM)
Mardi Gras Bachelors*
Mystical Belles*
Mystics of Time (MOT)
Nereides
Order of Athena
Order of Juno
Order of Myths (OOM)
Original Dragons
Original Utopia Club
Pierrettes
Polka Dots
Santa Claus Society (SCS)
Spinsters
Strikers
Strikers Social Club

PARADES AS OF 1962

Arrival of King Felix III
Comic Cowboys
Crewe of Columbus
Daughters of Venus*
Davis Avenue Children's Parade
Floral Parade
Infant Mystics (IM)
Jolly Jesters*
Knights of Revelry (KOR)
Maids of Mirth (MOM)
(*No longer in existence)

Mobile Area Mardi Gras Association
(MAMGA)
Mystic Stripers
Mystical Belles*
Mystics of Time (MOT)
Order of Athena
Order of Myths (OOM)
Parade of the Mobile Carnival
Association (MCA) King and Queen
Polka Dots

When Julian "Judy" Rayford published his book *Chasin' the Devil Round the Stump, History of Mardi Gras 1904–1962*, he revived the memory of Joseph Stillwell Cain by leading the effort, as mentioned earlier, to have the bodies of Cain and his wife exhumed from their Bayou La Batre graves

and re-buried by city proclamation in the old Church Street Graveyard in downtown Mobile. This made Joe Cain the first to be buried there since the graveyard was closed to further burials in 1898.

On Shrove Sunday in 1966, one hundred years after Joe Cain paraded with his Lost Cause Minstrels as Chief Slacabamarinico (Ol' Slac) through the streets of Mobile, Julian Rayford created a jazz funeral procession the very day of the re-internment of Joe Cain and his wife along with the Excelsior Band of Mobile. About one hundred friends and persons of interest in costumes of various types, dogs in costumes and people pushing babies in strollers marched in colorful procession from the foot of Government Street into the old graveyard.

This annual procession honoring Ol' Slac soon became known to all and grew quickly in size. Within ten years, the Joe Cain Procession had grown to thirty thousand participants and became known as the People's Parade. The event on Shrove Sunday had no connection to the many private mystic societies or the Royal Courts of the Mobile Carnival Association or the Mobile Area Mardi Gras Association, but it was considered the common man's Mardi Gras celebration.

The procession began at the foot of Government Street and proceeded fourteen blocks to the Church Street Graveyard, located behind the main branch of Mobile's Public Library. There the city would provide a jazz band at one side of the graveyard and a rock band at the other—yes, in the graveyard! Families were known to erect cabanas over their family members' graves and have cocktails and brunch on top of the deceased.

At the head of the procession would be Julian Rayford dressed as Chief Slacabamarinico. Following in open Cadillac convertibles were several women dressed in 1800s funeral attire of black dresses to the ground and full veils, all claiming to be Ol' Slac's widow. The identities of these women were as closely guarded a secret as in any Mardi Gras society. When the Widows arrived at the graveyard, they awaited the throngs of revelers at the entrance to the graveyard. A stage was built over Cain's grave, upon which the mayor proceeded to introduce each widow with each of their fictitious names, old southern favorites such as Sue Ellen, Zelda, Tara, Savannah, Magnolia, Camellia, Georgia and others. The music began, and the festive occasion lasted into the late afternoon.

This celebration would soon outgrow its charming location due to the damage being done, over time, to this very historic graveyard, which includes veterans of the Revolutionary and Civil Wars, as well as the oldest Jewish graves in the state, not to mention a few of the oldest trees in the country.

Moving the Joe Cain Procession was not an easy task. A move to the Civic Center's parking lot only seemed to irritate the public. However, the event continued to grow and quickly became the largest parade and party of the season. Eventually, the city decided to turn the event into an organized parade following the popular two-and-a-half-mile principal parade route.

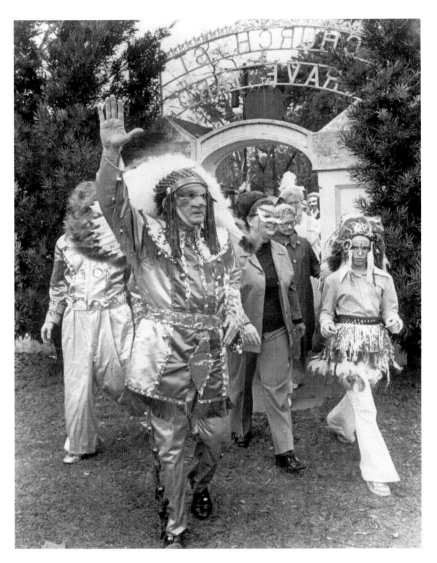

J.B. "Red" Foster as Slacabamarinico, circa 1970. *Photo courtesy of Clarence Keller, the Doy Leale McCall Rare Book and Manuscript Library, University of South Alabama.*

Soon it was J.B. "Red" Foster who portrayed Chief Slacabamarinico, the third Mobilian to have the honor. He led the parade in Cain's old coal wagon for fifteen years. Then it was local minister and author Bennett Wayne Dean Sr. who assumed the position of chief in the mid-1980s through the time of this writing. Following Ol' Slac were the now well-organized Merry Widows of Joe Cain on their "funeral float." By the twenty-first century, there would be another group of women prominently positioned at the beginning of the parade: Joe Cain's Merry Mistresses.

After the widow's float were processions of folks in costumes and homemade floats, some quite elaborate, made by groups of friends or families organized into faux societies, giving themselves names such as Historic Order of Dead Rock Stars, J.B.'s Party Crew, Knights of Daze, Montrose Cain Raisers and many more.

By the late 1980s, the Joe Cain Parade had become a spectacle to watch as well as in which to participate. In time, the Joe Cain Parade, the People's Parade, would bring over 150,000 revelers into downtown Mobile on Shrove Sunday.

From the *Mobile Register* of Ash Wednesday 1978:

> *As Mardi Gras ends and Lent begins, anyone who participated in the carnival season must agree that 1977 was probably the most joyful and successful on record. The reason, to a large degree, was the immensely popular Joe Cain Procession Sunday—a credit to the innovative mind of Judy (Julian Lee) Rayford and some of his friends. Prior to the inaugural of this tribute to the man who revived Mardi Gras in Mobile after the Civil War, the carnival season had little or nothing to offer the general public. Only those who could afford the usually considerable expense of belonging to a mystic society enjoyed the role of participant: everyone else was a spectator. But there were more participants than spectators Sunday as the Joe Cain Procession firmly entrenched itself as an integral part of Mobile Mardi Gras.*

The 1970s and '80s were two decades of relatively slow Carnival growth compared to many other twenty-year periods. The only parading and ball societies formed were the Conde Cavaliers (1977), the Pharaohs (1983) and the La She's (1989). Ball-only societies formed during this time were Order of Osiris (1980), Crew of Don Q (1985), Mardi Gras Maskers (1986) and the Resurrected Cowbellion de Rakin Society (1989). The Northside Merchants are a parade-only group dating to 1989, according to the *Mobile Mask*, and some know it as the Robert Battles Motorcade.

The Conde Cavaliers were originally named the Fort Conde Cavaliers but soon dropped the "Fort" from the name to honor the celebrated French general Prince de Conde for whom Fort Conde in downtown Mobile is named. They requested and were given permission from the Conde family of France to feature the Conde family coat of arms on the doubloons thrown at their first parade. Since their founding in 1977, this parading society has been given the honor of being the first parade of Carnival season—for good reason, because these guys know how to put on a show! Their floats and costumes are always spectacular. Their Emblem and permanent floats consist of a full-scale locomotive engine, cars and caboose all ablaze in color. And, most importantly for the kids, the members throw lots of candy, beads and trinkets.

The Pharaohs are an interesting mystic society that began in 1985, founded by Terry J. Guthrie, who was also a member of a New Orleans krewe. He wanted to incorporate some of New Orleans' Carnival practices while respecting Mobile's traditions. This was the first mystic society to publicly acknowledge its selected royalty of the year, which included the "Queen of the Nile" as Queen and "King Tut" as Emblem (Leading Man). All of their Emblem and permanent floats reflect ancient Egyptian culture.

Founded in 1980, Order of Osiris was Mobile's first gay and lesbian mystic society. By the twenty-first century, there would be two more, Phoenix and Pan. Osiris is a ball-only organization known for its elaborate tableaux. Osiris presents a two-and-a-half-hour Broadway show–type tableau, with all guests seated at tables adorned with elaborate settings reflecting the theme of the year. Many table sets often include moving parts and can reach up to ten feet above the table. This spectacular event generates a great demand for invitations for the ball, with attendance limited to about 1,500 guests.

As the twentieth century drew to a close, ten more mystic societies would form in the 1990s, and nine more would be organized in the first decade of the twenty-first century. Of those nineteen, fifteen societies would have parades.

By 2014, there were about sixty-five mystic societies, thirty-five of which have parades. Modern Mardi Gras is as big a festival as it was in the late 1800s. Just as then, today's Mobile Mardi Gras and Carnival season is the nation's second-largest community festival, with New Orleans being the largest. However, Mobile remains the "Mother of Mystics," claiming the first Mardi Gras Day celebration in 1703 and the first mystic society in 1704. New Orleans was founded in 1718.

Part II

MODERN MARDI GRAS

Chapter 6
Mystic Societies and Balls

In Mobile, Mardi Gras comes with the seasons, a natural phenomenon, an event to be anticipated and enjoyed, but not really to be considered anything very unusual. One simply grows up knowing that Mardi Gras will come with the spring.

Yet, as is true of all such casually successful productions, the spectacle consumes in its creation unbelievable amounts of money, time, and thought. Like opera, it combines arts, and it has a tradition of grand scale. There is no such thing as a small, quiet, cheap Mardi Gras which is also successful.

Mobile has long prided herself upon the fact that her carnival is essentially a local festival. It is created by Mobilians for the enjoyment of Mobilians. Visitors are welcome, of course, but the spectacle is not designed to awe strangers. Its appeal basically is to those who are familiar with the form and able to recognize nuances of design and execution. That a local festival should be staged on such a grand scale and at such a high artistic level makes it unique in the country.
—*Caldwell Delaney, 1986*

As of the second decade of the twenty-first century, there are about sixty-five mystic societies in Mobile. Some are long-lived, and some will be short-lived.

Mystic societies are often referred to as Mardi Gras organizations, and it is perfectly acceptable to ask a Mobilian, "To what organization(s) do you belong?" Most likely this custom is due to the fact that "mystic" implies secrecy, and because of social media in our modern world, many organizations are no longer secret with their membership rosters or rituals.

Sometimes these societies are referred to as krewes or, in one singular case, crewe—the Crewe of Columbus. If you are inquiring about a membership in Mobile, no one will be offended, however you ask!

Mystic societies are similar to collegiate sororities and fraternities. Not only do they have a formal ball during Carnival season, many with parades preceding their balls, but they also have meetings, receptions and less formal parties throughout the year. Memberships may number as few as fifty or as many as five hundred.

About half of the mystic societies have parades that precede their balls, and the remainder only have a ball. A few societies and other kinds of groups only hold a parade.

There are a few parades, such as the Floral Parade, the MLK Business and Civic Parade and the Mammoth Parade, which are not hosted by mystic societies at all but are presented by Carnival associations or civic organizations.

The Order of Myths, our oldest parading society, holds a reception on the Sunday prior to Mardi Gras Day at noon, and similarly, the Knights of Revelry hold a reception following its parade on the afternoon of Mardi Gras Day.

Balls are formal affairs, each with a strict dress code called costume de rigueur, which requires ladies to wear gowns to the floor and men white tie and tails, just as at a formal wedding. No military uniforms or colored accessories are allowed for the men.

Receptions, which are balls held during the day, require ladies to wear cocktail dresses and men to wear coat and tie. At the two oldest society receptions, hosted by the Order of Myths and Knights of Revelry, most ladies

Ladies in hats, 2010. *Author's collection.*

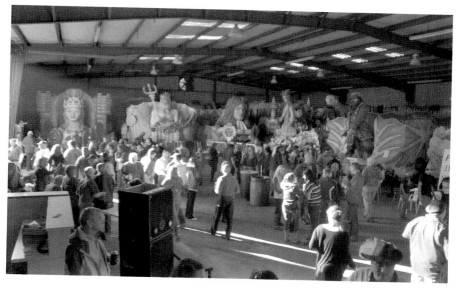

Conde Cavaliers float barn party, 2014. *Author's collection.*

adorn themselves with lovely hats, many oversized and custom-designed by such local designers as Jessica Price and Gloria Good. Gloria is also known for her parasol designs for the second line dance at the Comrades Ball. It has been said that Mobile has several occasions where ladies wear fabulous hats, whereas the Kentucky Derby has just two events.

Mystic societies that have parades preceding their balls hold "float barn" parties. These parties will often bring as many invited guests as a ball and are held at the warehouse where permanent floats are stored and new floats are designed and built in keeping with the year's ball theme. This party is very casual and allows members and their guests a private preview of the floats for the upcoming Carnival season.

The older the mystic societies, the closer to Mardi Gras Day their balls and parades will be held.

MYSTIC SOCIETIES IN MODERN MOBILE, OLDEST TO NEWEST

FOUNDING DATE	NAME
1842	Strikers Independent Society (ball only)
1867	Order of Myths (OOM) (parade and reception)
1869	Infant Mystics (IM) (parade and ball)
1874	Knights of Revelry (KOR) (parade and reception)

FOUNDING DATE	NAME
1884	Comic Cowboys (parade only)
1888	Dragons (ball only)
1888	Santa Claus Society (SCS) (ball only)
1910	Spinsters (ball only)
1914	Sirens (ball only)
1917	Midnight Mystics (ball only)
1921	Crewe of Columbus (parade and ball)
1921	Follies (ball only)
1927	Fifty Funny Fellows (FFF) (ball only)
1933	Strikers Social Club (ball only)
1935	Original Dragons (ball only)
1936	Utopia Club Inc. (ball only)
1936	Thalians (ball only)
1938	Neriedes (ball only)
1939	Mobile Area Mardi Gras Association (MAMGA) Grand Marshal's Ball (ball only)
1939	Mystic Stripers Society (parade and ball)
1940	Order of Juno (ball only)
1946	Comrades (ball only)
1947	Krewe of Elks (ball only)
1947	Pierettes (ball only)
1948	Mystics of Time (MOT) (parade and ball)
1948	The Sirens (ball only)
1949	La Luna Servante (ball only)
1940	Dominoes Double Rush (ball only)
1949	Order of Polka Dots (parade and ball)
1950	Etruscans (ball only)
1950	Maids of Mirth (MOM) (parade and ball)
1953	Harlequins (ball only)
1953	Don Domas (ball only)
1954	Order of Athena (parade and ball)
1956	Order of Inca (parade and ball)
1960	Athenian Civic Social Club (ball only)
1961	Le Krewe de Bienville (parade and ball)
1977	Conde Caveliers (parade and ball)
1980	Order of Osiris (ball only)
1984	Mardi Gras Maskers (ball only)
1985	Pharoahs (parade and ball)
1985	Original Don Q Inc. (ball only)
1989	Emeralds (ball only)
1989	Order of LaShe's (parade and ball)

Founding Date	Name
1989	Resurrected Cowbellion de Rakin Society (ball only)
1990	Marquis De Lafeyette Societie, Inc. (ball only)
1990	Monday Nighter's Supper Club (ball only)
1993	Krewe of Merry Mates (parade and ball)
1995	Neptune's Daughters (parade and ball)
1997	Mobile Mystical Ladies (parade and ball)
1997	Knights of Mobile (parade only)
1999	Order of Rolling River (parade and ball)
2000	Order of Butterfly Maidens (parade and ball)
2000	Order of Venus (parade and ball)
2004	Conde Explorers (parade and ball)
2009	Krewe of Pheonix (ball only)
2009	Order of Isis (parade and ball)
2010	Order of Hebe (parade and ball)
2010	Krewe du Bon Temps (ball only)
2012	Mobile Cadets (parade and ball)
2012	Moonlight Maidens of Mobile (ball only)
2012	Mystic Order of NYX (ball only)
2014	Order of Pan (ball only)

Mobile has several venues large enough for today's large Mardi Gras balls, which may have as many as six thousand guests. They include such venues as the Mobile Civic Center, Mobile Expo Hall and Mobile Convention Center. Smaller venues include armories, clubs and hotels.

Before World War II, balls were smaller and could be housed in local clubs and hotel ballrooms. If attendance surpassed those venues, balls and royal coronations were held in wharf warehouses, which were richly decorated for the festive occasions.

Ball Venues over Time

Late 1800s

Armory Hall
Athelstan Club
Battle House Hotel
Cawthon Hotel
Manassas Club
Princess Theatre
Temperence Hall

EARLY 1900S
 Admiral Semmes Hotel
 Athelstan Club
 Battle House Hotel
 Cawthon Hotel
 Fort Whiting Armory
 German Relief Hall

LATE 1900S–PRESENT DAY
 Abba Shriner Temple Auditorium
 Alabama Cruise Terminal
 Athelstan Club
 Fort Conde Courtyard
 Fort Whiting Armory
 Greater Gulf States Fairgrounds
 Mobile Civic Center
 Mobile Convention Center
 Mobile Expo Hall
 Mobile Government Plaza Atrium
 various hotel ballrooms

The designs and ballroom decorations are important aspects of every ball. One of Mobile's preeminent designers of the grand spectacles is Ron Barrett, who has been making Mardi Gras magic for over thirty years. He may stage as many as forty balls a year and often designs elaborate attire for the Royal Courts.

Ron has a core crew of nine people, but during Carnival, that crew can swell to thirty. His partner, Jim Sapser, and Julia Greer Fobes are his "right arms," and as he says, "They make the magic!"

Costumes are an important part of Carnival season. Costuming in Mobile is practiced by almost all of our mystic societies and, with few exceptions, not by individuals on the street. Many visitors and townspeople enjoy sporting decorative masks but seldom wear full costumes at parades and on Mardi Gras Day.

Mystic societies, parading or not, have organized costume rituals. A Leading Lady or Man, who is equivalent to a prom queen or prom king, will have a custom-made costume to reflect the theme of the year. For instance, if the theme were "The Wizard of Oz," the Leading Lady may appear as Dorothy or perhaps Glinda, the Good Witch of the South.

Ron Barrett, 2014. *Author's collection.*

There is likely an Emblem Girl or Guy whose costume reflects the society's emblem or mascot, for example, the Infant Mystics' Hissing Cat or the Order of Myth's Folly.

Many new organizations that select a King or Queen, rather than a Leading Lady or Man, will often have costumes that are similar but smaller in scale to the designs of the gowns, robes and trains of Mobile's two Carnival associations' Royal Courts.

Usually only active members of the mystic societies are allowed to wear costumes. Often they are divided into groups of ten to twenty in order to reflect the theme for the year. For example, if the theme were "Broadway" ten may be dressed as characters from *Cabaret*, ten from *West Side Story* and ten from *The Wiz*. If the society has a parade, the floats would reflect the different aspects of the theme.

Today's most popular float costume designers are Andrade's Costume House and Bienville Costumes. Andrade's has been making costumes for over fifty years and may make as many as 2,700 costumes in one year, according to Julie Andrade Jones, daughter of the founder of the company.

Almost one-third of the mystic societies are ladies' societies, and about two-thirds are gentlemen's societies. A few are couples societies. Some are predominantly white, while some are African American. Three are predominantly gay and lesbian. Some are single men only, and some are single women only.

Most balls are by invitation only. However, with so many balls, newcomers are often invited informally or even on the spot to one or more balls. There are balls to suit all tastes. The oldest balls and receptions are more selective with their invitation lists, and persons invited would never be expected to pay for the honor of being invited. Most newer balls are larger and more inclusive but may request payment for invitations. These invitations are referred to as "tickets."

For example, if you had several friends visiting for the Carnival celebration, you may ask a friend who is a member of one of the larger mystic societies if you and your friends may attend his or her ball. Your friend may be kind enough to offer you the invitations free of charge, or he or she may request $50.00 each or $100.00 a couple for invitations, which would then be referred to as "tickets." The invitations may be quite elaborate, with enclosures containing frameable artwork.

Mystic societies vary in number of members, types of memberships, types and number of committees, selection of leaders and types and number of social activities. One of the largest men's organizations, the Crewe of Columbus, with membership near six hundred, has membership levels of associate, active, honorary and lifetime honorary. Officers are elected for two-year terms and include the posts of admiral, first vice-admiral, second vice-admiral, treasurer,

Strikers Ball invitation, 1883. Published in *A History of the Strikers 1842–1997. Mobile Carnival Museum Collection.*

corresponding secretary and recording secretary. There are at least ten committees, and each will have a chairman.

A Leading Man, selected by the officers, portrays Christopher Columbus at the parade and the ball. This gentleman's daughter is selected as Queen and

rides in a white horse-drawn carriage preceding her father on the Emblem float at their parade. The parade has six permanent floats and twelve floats that are built new each year based on the theme of the ball. Other social activities include two float barn parties when the floats are finished—one for members only and one for members and family. A Queen's reception is held earlier in the year for the new Queen, and a summer party is held as well.

The first Mardi Gras ball I ever attended was hosted by the Crewe of Columbus in 1981. The extravagance of the affair was overwhelming for a young man fresh out of college and originally from a small town. I had never attended a social function on such a grand scale! It was amazing to see thousands of grown men and women of all ages dressed to the nines in white-tie tails and gowns to the floor looking more like the red carpet celebrities at the Oscars than what you would expect from residents in a small southern city. We all took our seats in the Civic Center Arena, waiting for the members to arrive from the floats of their parade, which had just wound through the streets of downtown Mobile.

My invitation, which I had presented at the entrance, told me the room number that had been assigned to my host. I was told that if I were to ever see my host, Mr. Billy Partridge, room "H" of the twenty-six rooms, A through Z, which circle the Mobile Civic Center beneath the arena seats, would be the most likely place. What I did not realize is how difficult this search would be due to the fact that there are twenty-six rooms filled with hundreds of quests. In each room, I found buffets of food and table after table, covered edge to edge, with various mixed drinks.

The doors closed at 9:00 p.m., and the show began! The tableau, as mentioned earlier, is a theatrically staged introduction of costumed members. The Crewe of Columbus' tableau features its Leading Man, Columbus, standing atop a ten-foot diameter globe, atop a mountain setting with six American Indian chiefs in full headdress. Behind it all, pyrotechnics lit the stage and the members filed out, descending to the dance floor while Neil Diamond's hit song "Coming to America" excited the crowd.

After the members had the first dance, the throngs of guests poured onto the dance floor, which was the size of a basketball court.

Music was provided by Lester Lanin and his Orchestra in the main arena, while in the side halls of the arena, rock and jazz bands played for younger guests.

Ladies societies have become an important part of Carnival season. A typical ladies' society may have one hundred members or more. Often, membership consists of associates, active and honorary members. Associates are not yet "active," and active members may be limited to as little as a

seven-year term and then may become honorary. Members must be at least twenty-one years of age, though some societies restrict age to at least twenty-seven. A nominating committee, often appointed by the President and Leading Lady, receives nominations by active members.

Ladies' societies officers are elected but often first nominated by a nominating committee. There may be several committees such as ball, entertainment, food, tickets, costume, venue and theme. Societies with parades will have more committees.

Most ladies' societies elect a President as well as other officers. However, a Leading Lady, or Queen, and an Emblem Girl are usually selected by the President or by committee. Often the President becomes Leading Lady the following year and will choose the theme for the ball and/or parade. The Emblem Girl will wear the Emblem costume and serves as liaison between the general membership and committees. She is often the most popular girl in the organization!

The tableaux of ladies' societies are usually shorter in length, and their balls are often attended by hundreds but seldom thousands.

One ladies' society divides its membership into different host rooms, just as many men's societies do. The rooms may reflect different personalities, as special groups of friends with similar tastes will go all out to impress their guests. Year after year, one room may be known for its food and one for its inventive decorations. Some members may group together so that the settings of several rooms coordinate.

During the year, ladies societies have many more parties than those of their male counterparts. These may include fancy teas or receptions for the chosen Leading Ladies or Queens where all the ladies dress in fancy hats and white gloves. Themed parties may be held with themes such as "The Roaring Twenties," "Wild Wild West" or "Halloween." There may be a "new members" party, a pre-ball party and, if there is a parade, a float barn party.

Couples' societies are organized similar to men's and women's societies, but there are often co-presidents, usually one of the couples. They have elected officers and committee chairpersons. Receptions and parties are held throughout the year. One couples' mystic society, the Harlequins, has the signature position of having the first ball of Carnival season each year in November.

A popular mystic society event taking place on the Sunday before Mardi Gras Day is the Order of Myths Reception. Held around the group's "den," or meeting house, in DeTonti Square Historic District, several city blocks are closed to the public. Only members and guests are allowed entry into the cordoned-off area. Between two and three thousand invited guests arrive in

Kim and Douglas Kearley at the Order of Myths reception, 2010. *Author's collection.*

the early afternoon. The men are dressed in coats and ties and the ladies in cocktail dresses and fanciful hats.

Each of these ladies really knows how to wear a hat! They are often made by local hat designers, such as Jessica Price. Many are store-bought from

faraway places such as Atlanta or New York City and then embellished locally with flowers, feathers and rhinestones.

A jazz band entertains members of the crowd while they feast on delicacies such as boiled shrimp filling small fishing boats and oysters offered three ways: on the half shell, roasted in fire pits and crispy fried. Popular drinks include mimosas, Bloody Marys, martinis and "Chrissies," a popular ice cream drink.

This affair replaced the Order of Myth's ball about twenty years ago. At that time, the members decided it was simply too exhausting to put on a ball after their parade. The OOM parade is the last parade of Carnival season and rolls on Mardi Gras Day evening because it is the oldest parading society. After several days of attending balls, parties and parades, the society members were simply too worn out to have a formal ball on the last night of Carnival. Their last ball was in 1996.

Gay societies, too, often have active, associate and honorary memberships and elect officers for one or more year terms. Officers often appoint the various committee chairpersons. In general, the gay societies have more parties during the year than other societies. These may include road trips to New Orleans or the Mississippi Gulf Coast casinos. Pool parties, cookouts and holiday parties round out an active social year.

There are standout differences in the gay mystic societies. One is the selection and gender of a King and Queen. Most societies choose a Leading Lady or Leading Man. Some newer societies select a King or Queen, and still others may choose an Emblem Guy or Girl along with a King or Queen. All these honorary positions are for those members who are standouts within the organization. They may have given to the organization of their time and money, along with a giving and gracious personality. Often the gay organizations will not select a King and Queen until the night of the ball at the end of the tableau. The monarchs may be of either gender. There may be two Kings or two Queens. However, one year at a Krewe of Phoenix ball, two men were selected monarchs—one presented himself as King, and the other presented himself as Queen.

The tableaux of these gay societies are known for being long and elaborate. I have attended more Order of Osiris balls than any other and can tell you that their tableaux are similar to watching a Broadway show! Many folks attend this ball for the tableau alone, which may last as long as two and a half hours. Because at the gay balls everyone has a seat at a host's table, the tableau is most enjoyable.

In addition, the hosts', or members', tables are another reason to acquire an invitation (or ticket) to the gay balls, which are usually sold out by the

prior November! Each member decorates his or her table(s) for the ball, as do members of many other smaller balls, which also have seated tables. However, the gay society members go all out. I remember an Order of Osiris Ball with the theme "Broadway Shows." One table represented New York City. In the center stood a ten-foot tall replica of the Empire State Building. Another table represented *Grease*, with dolls dressed in 1950s costumes riding in miniature jalopies, all revolving around a five-foot-tall tiered revolving centerpiece!

Each year, Mobilians anxiously await ball reviews by the Masked Observer, "a mysterious denizen of the leisure class," who covers the local Mardi Gras scene. He writes exclusively for the *Mobile Press-Register*, now part of http://www.al.com. The Observer's identity was once a well-kept secret, as were those of his compatriots, Dark Hallway and Floral Headpiece. The following is a recent review of an Order of Osiris Ball:

Order of Osiris Ball Awash in Fabulosity
Men in evening gowns. Women in white tie and tails. Mobile's naughtiest politicians and most ridiculous social foibles simmering in a salty satirical stew.

And that was just the first five minutes.

The Order of Osiris Ball is like watching a head-on collision between the Comic Cowboys and a Glee *marathon.*

The faithful subjects of King Anthony XXIX and Queen Michelle XXIX gathered Friday night at the Mobile Civic Center Arena for the 30th convocation of Mobile's most fabulous mystic society, and the one most qualified to tell you which tie goes with which dress shirt.

Floral Headpiece, the Observers ever-proper social secretary, had gone out of her way to prepare for their evening out at this special venue.

"Now promise me you won't embarrass me," she kept saying. "You're both so phobic at times."

"Nonsense," The Observer told her. "Dark Hallway may look tough, but he's a huge Streisand fan. Got every movie she ever made, including Yentl.*"*

Osiris has its own ways. Instead of the usual 9 p.m. start, guests arrive by 7:30. By 9, the doors close, and they aren't kidding.

Things started with a sublime and respectful rendition of "The Star Spangled Banner"—better than what Super Bowl fans got.

Osiris has its parade inside, if you will, and the royal couple took several turns around the arena floor in their royal carriage. Past royalty got a gracious nod as well.

A young thing named Sweet Pea undulated the crowd into a state of near euphoria, but they had already been warmed up by semi-clothed exotic dancers spread about like living sculptures.

The Observer got pulled into a gaggle of young men waiting in a bar line, who were listening to one of their own complain about what he'd been put through by his date.

"I had to walk all the way back to the hotel to get her shoes!" he groused in a good-mannered way. "My feet are killing me, and now I can't find her!"

Wearing just the right accessory is important to this krewe. Happily, the couple was eventually reunited, and one presumes his efforts were rewarded.

On the dance floor of the arena, the Order of Osiris had a radical robotic boom camera catching all the actions and transmitting it to oversized video screens above.

"It's the only way for everyone to see what's happening," a young lady remarked to the Observer in yet another bar line. "I go to a lot of Mardi Gras balls, and to me, this one is like going to a Broadway show."

As for the topics covered, there was the Spanking Judge, of course. There was commentary about wayward priests and wild, wild women. The emblems Osiris, Isis, and Horace got their due diligence, of course.

The Observer's very first Mellow Moon Pie Award must go to the redhead in the green dress and the silver pumps who was the toast of her table, sitting on one lap and then another as the tableau unfolded.

Kudos must also be given to whoever thought of decorating each table with red charger plates, candelabra and red napkins.

The Observer also believes, based on unscientific but thorough sampling, that Osiris is the most successfully integrated Mardi Gras group in Mobile.

At some point, the Observer announced that he's had all the fabulosity he could stand and forced Dark Hallway to drive them back to the helipad for the short flight to Goat Island.

There are so many wonderful balls during Mobile's Carnival season. There is a ball for all tastes, so visit Mobile at Carnival. With a little luck and effort, anyone can get invited to a ball, and I promise it will be the biggest and most lavish spectacle of your life.

There is a congeniality, a friendship, true hospitality Mobile style…There are no strangers when you come to our Mardi Gras. You are suddenly ingratiated into a new group of friends, and you become a Mobilian for a day.
—Robby McClure, quoted in Lesley Farrey Pacey's "A Party of Epic Proportions," Sense magazine, February 2011

Chapter 7
Parades

"What is a Mardi Gras parade like?" I asked Mrs. Madeline Partridge. She, the mother of my college friend Bill Partridge, had asked me to join her for my first parade. "Why," she thought for a second, "It's like having a baby. If you've never had one, then there is no way I can describe it!"

She was correct. My first parade was hosted by the Crewe of Columbus, of which Mrs. Partridge's husband, Billy, was a member. The overwhelming, bigger than life, colorful pageantry of that parade sent goose bumps all over me—which still happens at today's parades. As my friend Deborah Velders, executive director of the Mobile Museum of Art, said, "It is like a medieval spectacle!" I would add, "On steroids."

Mardi Gras parades generate the largest turnout of any Mardi Gras event. In fact, for many people, parades are what Mardi Gras is all about. When attendance at all thirty-seven parades is counted, it totals over one million, and when adding attendance at all other events, Mobile's Carnival becomes the second-largest community festival in the nation each year!

Most parades precede mystic society balls and start in the early evening, usually at 6:30 p.m. A few afternoon parades are followed by daytime balls, called receptions. There are a few other parades during the day that represent organizations that are not mystic societies and a few that are produced by the Carnival associations to present their Royal Courts.

The Order of Myths, the oldest Mardi Gras parade in America, rolls on Mardi Gras evening at 6:00 p.m. All other parades proceed, oldest to newest,

in general, when the Conde Cavaliers kick things off eighteen days earlier on a Friday evening.

According to Julian Lee Rayford in 1962:

> *You have to see a Mardi Gras ball, you have to see a Mardi Gras parade—you have to see the color, the gold leaf and the silver leaf, the*

Mobile County sheriff Sam Cochran leading the Sheriff's Posse, 2010. *Author's collection.*

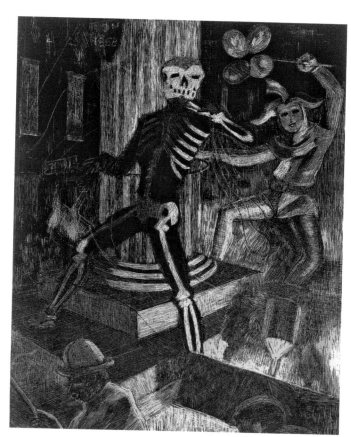

Left: *Folly Chasing Death*, by Carl deCelle, 1967. *Mobile Carnival Museum Collection*.

Below: 100th Anniversary Print of the emblem of the Sirens by Barbara Ann Guthans, 2014. *Mobile Carnival Museum Collection*.

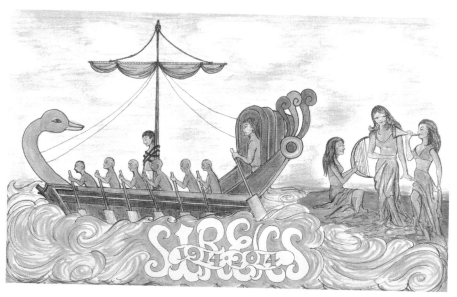

1939 1989

The Nereides
50th Anniversary

Above: Nereides fiftieth anniversary print, 1989. *Mostellar collection.*

Left: Order of Incas leader's costume, 2014. *Author's collection.*

Local designer Gloria Good,
2014. *Author's collection.*

Jessica Price wearing a
self-designed hat, 2014.
Author's collection.

Alabama State University Marching Band, 2010. *Author's collection.*

Olympia Brass Band, 2013. *Author's collection.*

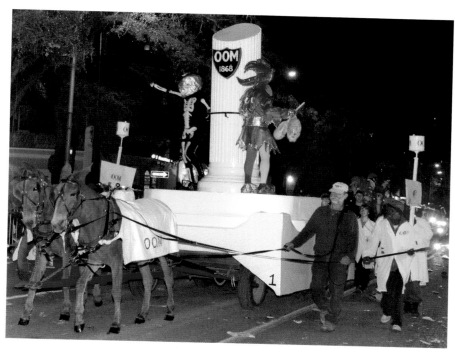

Order of Myths Emblem float, 2012. *Steve Joynt/Mobile Mask.*

Joe Cain's Merry Widows, 2014. *Author's collection.*

Joe Cain's Merry Mistresses, 2014. *Author's collection.*

MCA Queen's Luncheon table setting in honor of Queen Lynn Wentworth Morrissette, 2011. *Photo by Jeff Tesney, Mobile, Alabama.*

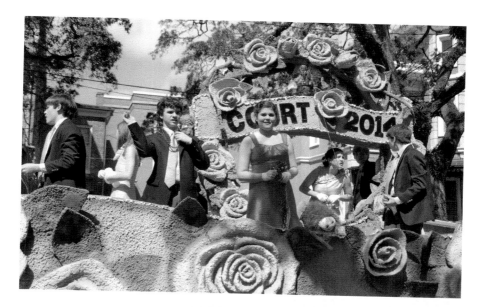

Above: A Juvenile Court float, 2014. *Author's collection.*

Right: MCA's King's float, King Felix III, Peter Cayce Sherman Jr., with Queen Louise Vass McClure, 2010. *Author's collection.*

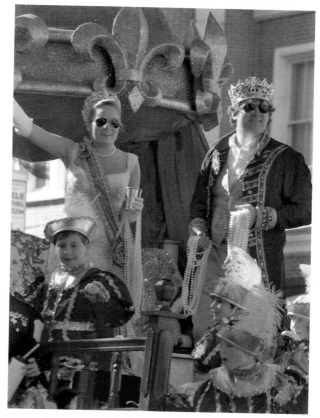

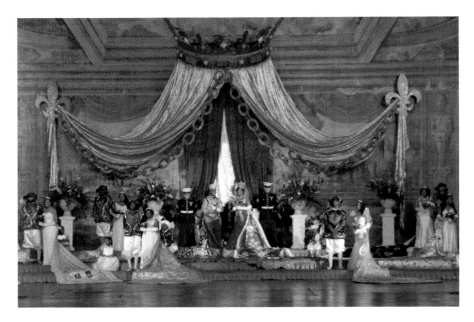

MAMGA coronation 2014 of King Elexis I, Bennie Morris Jackson III, and Queen Cecile Frances Green. *Author's collection.*

MAMGA Mammoth Parade, Mollies float, 2010. *Author's collection.*

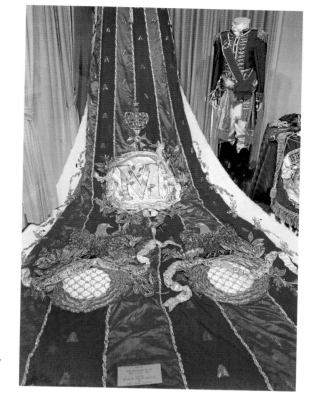

Train of MCA King Felix III,
David M. Mostellar, 1992.
Author's collection.

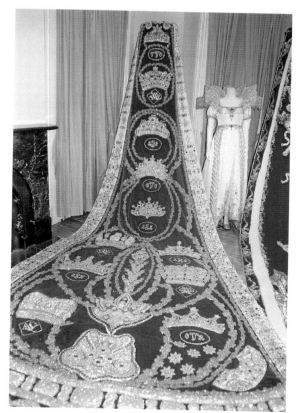

Train of MCA Queen Virginia
Oliver Van Antwerp, 2003.
Author's collection.

Left: Pat Halsell-Richardson with the train she designed worn by King Elexis I, Bennie Morris Jackson III, 2014. *Author's collection.*

Below: Crown of MAMGA King Elexis I, Jamarcus T. Russell, 2010. *Author's collection.*

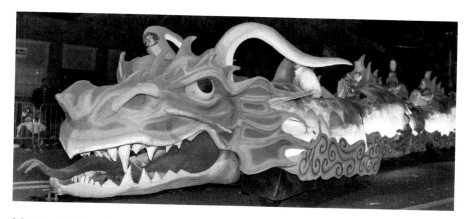

Mystics of Time, Dean the Dragon float. *Steve Joynt/Mobile Mask.*

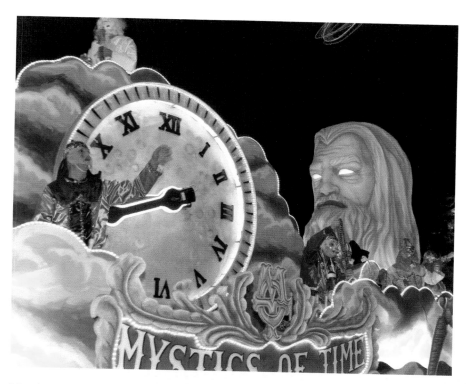

Mystics of Time Emblem float. *Steve Joynt/Mobile Mask.*

Knights of Revelry Emblem float. *Steve Joynt/Mobile Mask.*

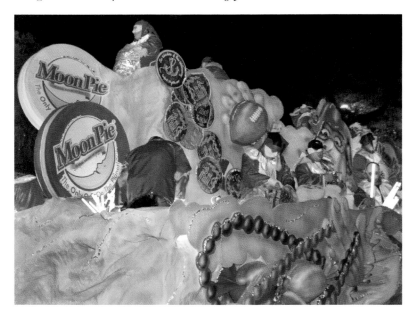

Infant Mystics Theme float. *Steve Joynt/Mobile Mask.*

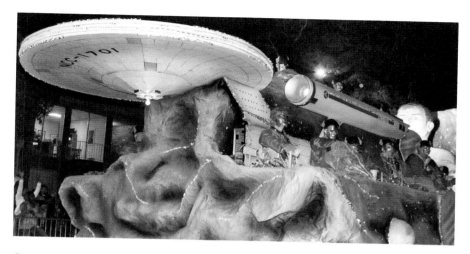

Crewe of Columbus float, 2012. *Steve Joynt/Mobile Mask.*

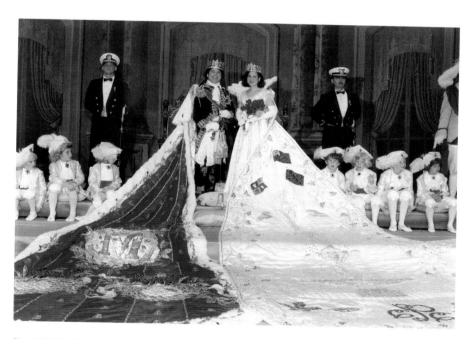

David M. Mostellar, MCA King Felix III, and Queen Celeste "Kitty" Peebles, 1992. *Photo by M&A Studios, Mobile, Alabama.*

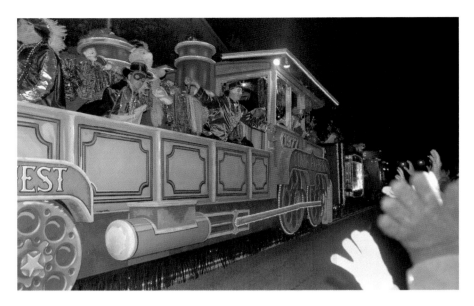

Conde Cavaliers, Train float. *Steve Joynt/Mobile Mask.*

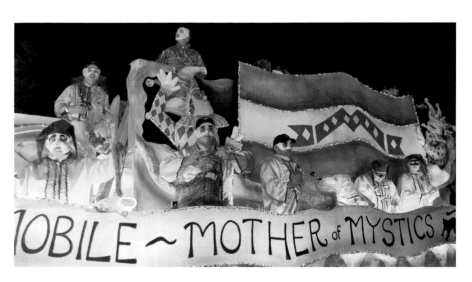

Infant Mystics, Theme float. *Steve Joynt/Mobile Mask.*

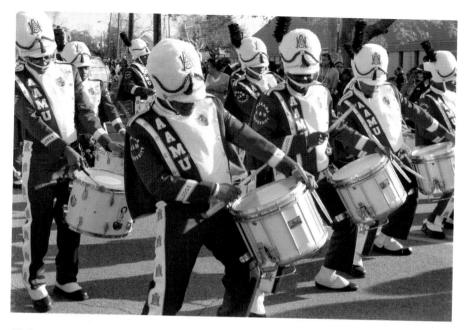

Alabama A&M University Band, 2012. *Steve Joynt/Mobile Mask.*

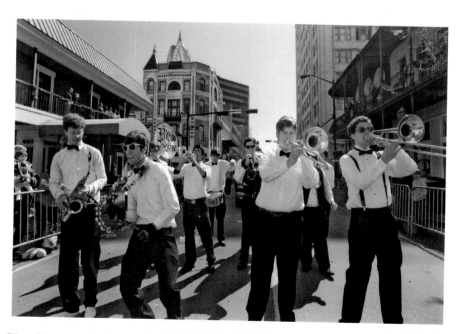

Blow House Brass Band, 2010. *Library of Congress.*

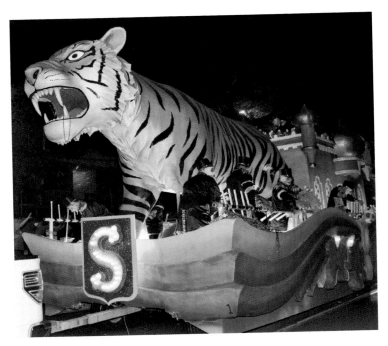

Mystic Stripers, Tiger float, 2012. *Steve Joynt/Mobile Mask.*

Order of LaShe's, Title float, 2012. *Steve Joynt/Mobile Mask.*

costumes—you have to enter into the whole unorthodox fantasy of the thing and see, not children but grown people, literally living out fairy tales, before you can believe it. And even then you won't understand it. Some folks say you have to be born in Mobile to comprehend it.

Parades are often led by men and women on horseback from the Mobile County Sheriff's Posse or the Mobile Mounted Police Auxiliary. These dedicated volunteers are often led by the sheriff or police chief, along with flags of a color guard.

Along the parade route, other mounted members flank the route keeping crowds "at bay" as the parade rolls. The crowd loves the beautiful horses that are well trained to be swarmed by crowds who pet and photograph them. Color guards of JROTC from various high schools may also lead or participate in parades.

Most parading mystic societies also have members on horseback participating in the parades. They are called marshals, and their costumes are among the most elaborate of their parade. They may appear at the beginning of a parade or between the various floats. Their favorite throws are doubloons, coins minted in aluminum with the organization's emblem and founding date on one side and the ball theme and current year on the other. Currently, each organization mints about twenty thousand doubloons each year, which are also thrown to the guests at their balls.

High school and university marching bands are another important part of a parade. These bands come from all over the region. There may be as many as fifteen bands appearing in one parade. The bands are paid to appear and are often brought in by bus and housed in hotels so they may appear in multiple parades. My friend David Schmol tells me the Infant Mystics have brought in such university bands as the Citadel and Virginia Military Institute (VMI). Visitors often wonder why hotel rooms are so scarce and expensive during Carnival. Part of the reason is that bands and locals take most of the rooms during the season. Part of the excitement of a parade is the many bands playing one after another, rolling down the street with majorettes dancing and prancing along.

Other important musicians of Mardi Gras include marching brass bands. Earlier brass bands like the Alliance Brass Band, Eureka Brass Band and the Onward Brass Band have faded into history, but the Excelsior Band dating to 1883 continues playing Dixieland and traditional jazz at parades, balls and many other occasions during the year. This band always introduces the first parade of Mardi Gras, that of the Conde Cavaliers. It plays in as many as

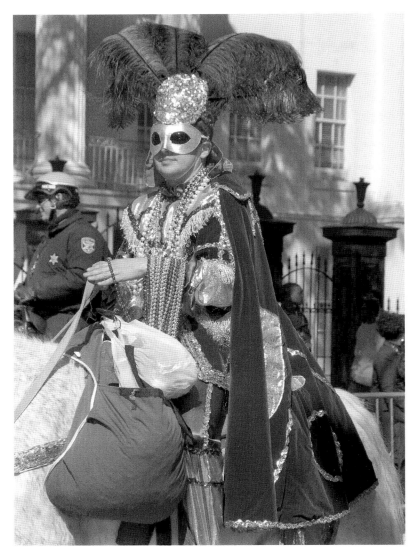

A Knights of Revelry marshal, 2010. *Author's collection.*

fifteen parades each year and consists of three trumpets, three saxophones, a trombone and a tuba, plus bass and snare drums.

Formed just over twenty years ago and founded by a former Excelsior Band member, the Mobile Olympia Brass Band is recognizable by members' bright gold shirts and the "official" clown who leads their way. This ten-piece band has also become a Mobile Mardi Gras music sensation.

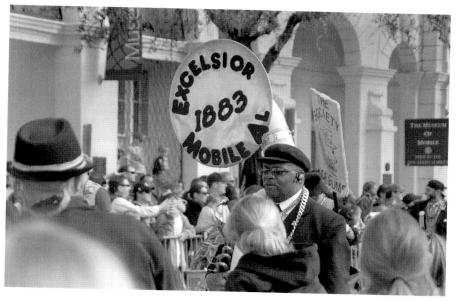

The Excelsior Band, 2010. *Author's collection.*

The first few floats are called permanent floats. They are saved for use each year in a "float barn," or warehouse. The first permanent float is often the "Emblem" float. It will have the society's name and founding date, giant representations of their mascot(s), which may be animals or Greek or Roman mythological gods or creatures, all designed at a height to just miss overhanging traffic lights.

Many of the larger nighttime parades will have several Emblem or permanent floats. Some parades will have just one or two. For example, the Infant Mystics members introduce their theme on the second of their two permanent floats that display their mascots—a hissing cat, an elephant and a knight in shining armor beside a cotton bale, all of which are displayed in giant caricature.

The Crewe of Columbus has five permanent floats. The first has Columbus and the American Indian chiefs, and the next are the floats that look like ships: the *Nina*, the *Pinta* and the *Santa Maria*. One more float, the Serpentine Float, has several intertwined serpents that appear to chase the three ships.

Behind the last permanent float will often be a float introducing the theme of the parade that year, which is also the theme of the ball that follows. The next floats, up to fifteen, will each reflect the year's theme.

An Infant Mystics theme float, 2010. *Author's collection.*

For example, a recent Infant Mystics parade, designed by the talented David Schmohl, had the theme: "How Does a Garden Grow." The Theme floats included Shifting of the Seasons, Worrisome Weeds, Tools of the Trade, Pestering Pests, Wondrous Water, Flourishing Flowers, Beneficial Bugs, Soaking Up the Sun, Fruits of Our Labor, Welcoming Wildlife and Gratifying Garden.

Newer parading organizations may borrow floats from older societies but never until after the older ones have had their parades.

One of the newer parading societies, the Butterfly Maidens, whose members in the past have used borrowed floats, added an interesting emblem to their parade. Instead of riding on a float, some members dress as gigantic butterflies reminiscent of costumed creatures from *The Lion King*. They are on the street fluttering around their floats as the parade rolls down the street.

Riding on floats can be a great family tradition. My friend James "Jimbo" Mostellar has paraded with the Infant Mystics for fifty years—long enough to see his dream realized: having all four sons ride with him in a recent parade.

Some of Mobile's most famous floats include:

Order of Myths Emblem: Folly chasing Death around the broken pillar of life.

Knights of Revelry Emblem: Folly dancing in the goblet of life.

Infant Mystics Emblem: A black cat atop a cotton bale, the foundation of Mobile's antebellum wealth.

Mystics of Time's Vernadean: A giant, rolling, fire and smoke–breathing dragon float.

Mystic Stripers Society: Two large forty-foot-long Emblem floats, one a ferocious and strong tiger and the other a sleek and fast zebra.

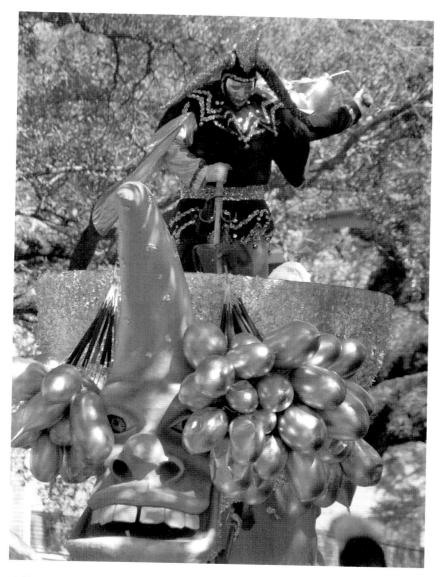

A Knights of Revelry Emblem float, 2010. *Author's collection.*

Crewe of Columbus's *Nina, Pinta* and *Santa Maria*: Three floats built to resemble Columbus's famed ships.

Order of Polka Dots: Famed Emblem featuring three winged sons of Pegasus bearing the Golden Chariot of the Gypsy Queen through rainbow-enveloped clouds.

Order of Inca Messengers and Sun Worshippers: Some of Mobile's largest moving structures.

Conde Cavaliers Emblem: Swashbuckler points his sword right at Mobile.

Comic Cowboys: Series of satirical comments on current events, local and national.

Thirty-one of the thirty-seven modern parades follow Parade Route A. This parade path is a two-and-a-half-mile route winding through Mobile's Central Business District.

There are many great places to watch the parades, and if you study the routes, you will be able to figure out how to see any parade from several locations, though you may have to run to do it!

I like to watch parades from balconies, but you will have to get yourself invited to stand there. They are all privately owned. Some hotels have balconies that allow guests their own lucky view.

The street level, however, is where the action is. It is the difference in watching a ballgame from a private box and sitting on the first few rows at the fifty-yard line or in front of the cheerleaders.

A Mystics of Time Emblem float, 2010. *Author's collection.*

A Comic Cowboys float sign, 2010. *Author's collection.*

A Mardi Gras float seen from a balcony, 2010. *Author's collection.*

I like to watch a parade first across from the Battle House Hotel where, atop the thirty-four-story RSA-BankTrust Building, a giant Moon Pie, fourteen feet in diameter, lights up and flashes as it falls on cables to just

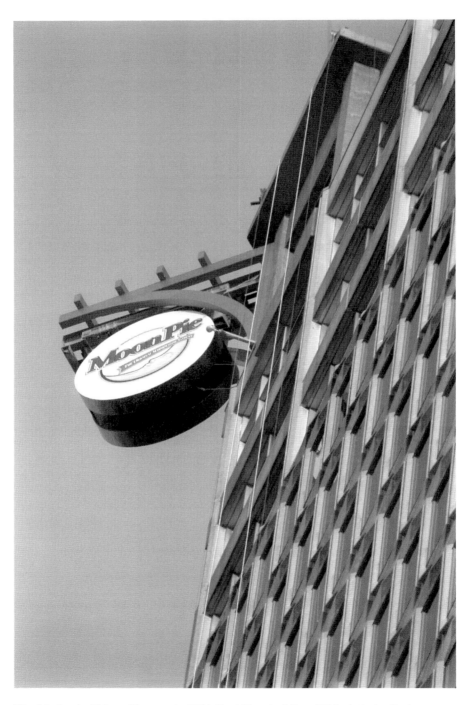

The Mechanical Moon Pie atop the RSA-BankTrust building, 2013. *Author's collection.*

above the crowd below, which applauds and screams. Its descent announces that the parade has begun a mile to the south and will arrive soon.

As the parade passes about halfway through, I run back to Bienville Square, where the floats take on a magical ambience viewed through the beautiful live oak trees. Then, at quick pace, I move south along Conception Street. This is the most narrow street on which the parade rolls. The floats are so close you can almost touch them. All the Moon Pies, candy, beads and trinkets whiz by you or strike you at alarming velocity. Then I run west on Government Street to Spanish Plaza, where there is plenty of space under more beautiful trees to relax as the parade rolls on, visiting more streets on the western edge of the Central Business District. There is, however, standing where I am, another opportunity to see the parade! It is coming back my way! Here, near where the parade will make its last turn onto Claiborne Street at the Mobile Carnival Museum, is the best place to catch lots of throws. At the beginning of the parade, the maskers (society members in costumes on the floats) are afraid they may throw all their throws away too soon, so by the end, they usually have a big stash left to throw. You may catch a whole box of Moon Pies and ten pounds of Mardi Gras beads, all in one spot!

The hundreds of beautiful floats built new each year must not only be meticulously designed to appear to be bigger-than-life expressions of an idea but also must be functional. Each float must handle the weight of up to twenty maskers who will each be loaded with over one hundred pounds of treats to throw to the crowd. Within the float must be a portable restroom, and sometimes there is even a wet bar.

Often the designs of the floats are created by a talented member of the society. For example, Edward Ladd or his son, Bradford Ladd, have designed floats for the Order of Myths, and David Schmohl has designed floats for the Infant Mystics.

Mobile has a history of talented float designers and builders. John Gus Hines and his son Emile Hines designed Knights of Revelry floats for the latter half of the nineteenth century. Others that followed were Edmond Carl deCelle, John Augustus Walker, Webb Odom, Joe Andrade, Andre Criminale, George Criminale, Ike Felis, Louis Colston and George Noonan. In 1962, Joe Andrade said, "You can't say there is nothing permanent about Mardi Gras. There is something permanent about it, because you carry the memory of it to the grave. I've heard lots and lots of people from out of town say they never saw anything like it. They think it's wonderful. They never forget it. That's the whole point of Mardi Gras—somehow, it's never forgotten."

Some of today's talented designers include Brent Amacher and James Finkle, as well as those who both design and build, such as George Danzy, Ari Kahn and Rhonda McCullough.

Mark Calametti is known not only for designing floats for the Crewe of Columbus and the Knights of Revelry for over fifteen years but also for his painting of the clever, satirical signs of the Comic Cowboys. He joins Joe Michelet, who has done the same for the Cowboys for decades. Mark is

Steve Mussell, pictured in 2014. *Author's collection.*

also the artist for much of the Mardi Gras memorabilia, as well as for the doubloon and medal designs for the mystic societies and Royal Courts, all commissioned through Toomey's Mardi Gras Warehouse.

Steve Mussell and his firm, the Mirth Company, have been in business since 1979 and employ ten full-time employees and up to six part-time artists, painters and carpenters. Some of his floats are for societies such as Knights of Revelry, Infant Mystics, Crewe of Columbus, the Stripers and Order of Polka Dots.

Craig Stephens, pictured in 2014. *Author's collection.*

Craig Stephens's firm, Carnival Artists, has been in business for almost thirty years and may employ as many as fourteen talented workers to build as many as seventy floats and refurbish over ten permanent floats each year for such societies as Order of Myths, Order of LeShes, Neptune's Daughters, Mobile Mystics and the Mobile Carnival Association's Floral Parade. Stephens also maintains all the permanent floats of the Mobile Carnival Association.

Lighting has been one of the more important aspects of float designs over the years. Desired effects of lighting in nighttime parades include glowing, shining, glistening and glittering. Early parades depended on flames of torches and flambeauxs. Later, incandescent light bulbs introduced the need for generators, usually pulled behind the floats. Fluorescent lighting is now most often used, but we are beginning to see the introduction of LED lighting to light the floats of Mardi Gras.

The goal of a lighting designer, such as George Criminale, is to achieve the perfect luminance without the crowds being able to see the source of the light, unless the light is the artistic subject—for example, a dragon's eyes. Electrical fires occasionally occur, in which case the flaming float is pulled to the side, maskers dismount and join another float and the parade goes on! This is why there is always a fire truck following the last float, and it signifies the end of the parade.

"Throw me something, mister!" These words are synonymous with Mardi Gras parading anywhere in America. Children and adults alike enjoy catching the goodies thrown from floats to the crowds along the parade route.

For years, the "throws" included hard candy, bubble gum, taffy, bags of popcorn and peanuts, serpentine (tiny rolls of colorful paper), confetti and Cracker Jacks.

In the 1950s, it was decided to ban confetti and Cracker Jacks. Confetti was banned because maskers were throwing it directly into the mouths of people in the crowd, causing them to choke, and Cracker Jacks were banned because the boxes were cutting people on the face.

As a result of the ban on Cracker Jacks, the now favorite throw, Moon Pies, made in Chattanooga, Tennessee, by the Chattanooga Moon Pie Company, were introduced. Now New Orleans throws candy and Moon Pies, too.

Strands of plastic beads and plastic trinkets were thrown in New Orleans at parades for years but were introduced to Mobile about fifty years ago and are now a favorite catch. Everyone tries to catch bigger and better beads than the next guy. Favorite bead catches include emblem beads, which are beaded necklaces with an attached plastic representation of the organization's

emblem. In fact, a local cosmetic surgeon has been renting billboards during Mardi Gras suggesting that women, in order to catch more beads, may wish to consider a free consultation.

Long arms are a great asset for catching throws. Other clever techniques for catching throws include holding an umbrella upside down, holding a small plastic swimming pool over your head or holding up a sign with the name of someone you know who is riding a float.

Don't be shy! It takes newcomers a few parades to get in the swing of things. It is sometimes hard to imagine adults grabbing Moon Pies and beads aside unfamiliar children doing the same. Most adults will share their catches with little children.

Steven Toomey—whose parents, Ann and Jack Toomey, opened Toomey's Mardi Gras Warehouse in 1976—has been selling Mardi Gras throws to most of Mobile's mystic societies for decades. What began as a seasonal business has become year-round with the company's online store.

Toomey's sells over five thousand different styles of Mardi Gras beaded necklaces. It sells over 3.5 million Moon Pies and over 51 million strands of Mardi Gras beads from the seventy-thousand-square-foot store, all of which will be tossed to the crowds.

The Moon Pies are made by the Chattanooga Moon Pie Company, and according to Steve Toomey's business partner, Chuck McVay, Toomey's is their

Toomey's Mardi Gras Warehouse, 2014. *Author's collection.*

biggest customer. Mobile will get special flavors such as coconut and caramel, made only for our Mardi Gras. As mentioned earlier, Mobile even went so far as to have a giant fourteen-foot-diameter metal reproduction of a Moon Pie placed atop our second-tallest building, the Trustmark Building, which lights, flashes and descends to just above the street at the start of each nighttime parade.

Now popular plastic cups thrown from floats and printed with all sorts of lists, flags and characters are also made by the tens of thousands in the United States for Toomey's each year.

The millions of Mardi Gras beads are made in China. The individual beads may be small or large, and the necklaces come in all lengths. Some may have additional decorations hanging from them including emblems, mascots, flags and various and sundry odd items.

Toomey's also sells the flags of Mardi Gras. Mobile's colors of Carnival are purple and gold—purple for justice and gold for power. The color green, which stands for faith, was added by New Orleans in the late 1880s.

Toomey's also does large custom orders for societies and other organizations. It has hundreds of thousands of doubloons minted. As mentioned earlier, these are coins thrown to the public at parades and to crowds at the balls. On one side is the society's emblem and founding date, on the other the theme of the year and date. They are made of aluminum specifically to be thrown. For members only, they are made of porcelain or bronze, and for the Leading Lady or Leading Man, doubloons may be

Cosmetic surgery billboard, 2010. *Author's collection.*

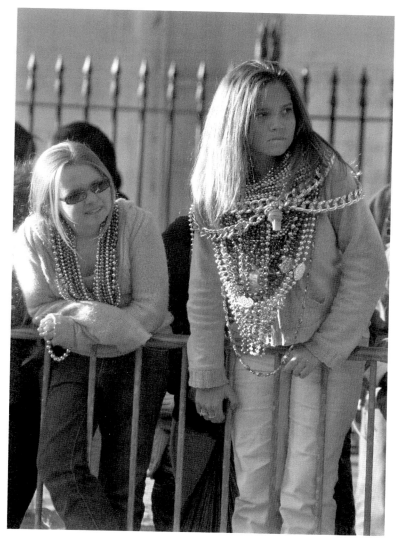

Girls with beads at a parade, 2010. *Author's collection.*

made of sterling silver or gold. Other custom orders may include medals or pins given to members of the Royal Courts, their families and friends, as well as custom beads, trinkets, cups and glassware.

King cakes are available at many bakeries throughout Mobile during Carnival season. These giant sweet rolls are covered in icing in the colors of Mardi Gras. A tiny naked baby, one half inch long, representing the

newborn baby Jesus, is nestled within the cake. The cakes are brought to a parade party, and the guest who receives the piece of the cake with the baby must bring a king cake to the next parade party.

There are a few important rules to follow when attending a Mardi Gras parade in Mobile. There are galvanized iron barricades lining the parade routes. These are to protect both the floats and those watching the floats. Before floats were as big as they are today and when they were pulled by mules, people were allowed to run right up to the floats. When the floats began to be pulled by tractors and pickups, running up to floats became dangerous, and several people lost their lives by being run over. Just before a parade, street intersection barricades will be locked along the parade route. You will be heavily fined if you are caught jumping a barricade.

Throwing any object into a parade is prohibited. Pets are restricted, as well as scooters, skateboards and firearms. There are items that are prohibited from being thrown from floats by maskers. They include rubber or any hard balls, wooden-handled objects, condoms, dolls with sexual organs, candy apples, canned foods or whole boxes of food.

Because Mobilians view Mardi Gras as a family affair, nudity, blatant public drunkenness and other lewd behavior are frowned upon.

As the fire truck passes, signifying the end of the parade, it is time to get out of the way. The clean-up crew is coming. Some say watching the clean-up crews after Mardi Gras parades is as fun as watching the parade—at a safe distance, of course.

Street-sweeping machines come barreling down the street, spraying high-pressure streams of water right and left with a force of a hurricane. The teams of uniformed workers with push brooms follow, and within the blink of an eye, it seems the tons of litter, broken beads and smashed Moon Pies are out of sight, and the city is sparkling clean again—just in time for the next parade.

Modern-Day Parade Schedule
(Subject to Change)

The calendar day of Mardi Gras Day varies each year, as does Lent and Easter. Parades are listed first to last in order of appearance. For example, Conde Cavaliers roll three days before Mardi Gras Day.

Conde Cavaliers	Friday, 6:30 p.m.	Route A
Order of the Rolling River	Saturday, 2:00 p.m.	Dauphin Island Parkway
Bayport Parading Society	Saturday, 2:30 p.m.	Route A
Pharaohs	Saturday, 6:30 p.m.	Route A
Order of Hebe	Saturday, 7:00 p.m.	Route A
Conde Explorers	Saturday, 7:30 p.m.	Route A
Order of Polka Dots	Thursday, 6:30 p.m.	Route A
Order of Inca	Friday, 6:30 p.m.	Route A
Mobile Mystics	Saturday, 2:00 p.m.	Route A
Mobile Mystical Revelers	Saturday, 2:30 p.m.	Route A
Maids of Mirth (MOM)	Saturday, 6:30 p.m.	Route A
Butterfly Maidens	Saturday, 7:00 p.m.	Route A
Krewe of Marry Mates	Saturday, 7:30 p.m.	Route A
Neptune's Daughters	Sunday, 6:30 p.m.	Route A
Order of Isis	Sunday, 7:00 p.m.	Route A
Order of Venus	Monday, 6:30 p.m.	Route A
Order of LaShe's	Tuesday, 6:30 p.m.	Route A
Mystic Stripers Society	Thursday, 6:30 p.m.	Route A
Crew of Columbus	Friday, 6:30 p.m.	Route A
Floral Parade	Saturday, 12:00 p.m.	Route A
Knights of Mobile	Saturday, 12:30 p.m.	Route A
Mobile Cadets	Saturday, 1:00 p.m.	Route A
Mobile Mystical Ladies	Saturday, 1:30 p.m.	Route A
Order of Angels	Saturday, 2:00 p.m.	Route A
Mystics of Time (MOT)	Saturday, 6:00 p.m.	Route A
Joe Cain Procession	Sunday, 2:30 p.m.	Route A
Le Krewe de Bienville	Sunday, 5:00 p.m.	Route A
MCA King Felix III and Floral Parade	Monday, 12:00 a.m.	Route A
MLK Business and Civic Organization	Monday, 3:00 p.m.	Route D
MLK Monday Mystics	Monday, 3:30 p.m.	Route D
Northside Merchants	Monday, 4:00 p.m.	Route D
Infant Mystics (IM)	Monday, 6:30 p.m.	Route A
Order of Athena	Mardi Gras Day, 10:30 a.m.	Route A
Knights of Revelry (KOR)	Mardi Gras Day, 12:30 p.m.	Route A
MCA King Felix III with Knights and Maidens Parade	Mardi Gras Day, 1:00 p.m.	Route A
Comic Cowboys	Mardi Gras Day, 1:30 p.m.	Route A
MAMGA Mammoth Parade	Mardi Gras Day, 2:00 p.m.	Route B
Order of Myths (OOM)	Mardi Gras Day, 6:00 p.m.	Route C

Parade routes and dates are subject to change. Always go to http://www.themobilemask.com for the most current schedule information.

PARADE-ONLY ORGANIZATIONS

Some organizations have a parade but no ball. They do have meetings and often small parties and fundraisers during the year. Several are official parades of the Carnival associations.

- Bayport Parading Society (Businesses)
- Floral Parade (MCA)
- Order of Angels (Philanthropic)
- Joe Cain Procession (Community)
- MLK Business and Civic Organization (Children)
- MLK Monday Mystics (Community)
- Northside Merchants (Business)
- Floral Parade (MCA)
- King Felix III with Knights and Maidens (MCA)
- Comic Cowboys (Private)
- Mammoth Parade (MAMGA)

There are children's parades, with sixty to eighty children participating in costumes with decorated bicycles, strollers and wagons. These are held in various subdivisions in town and date as far back as 1968.

- Krewe de la Kids (Heron Lakes)
- Mystics of Ashland Place
- Rosswood
- Hickory Ridge Kids Krewe
- Order of Impalas (St. Ignatius)

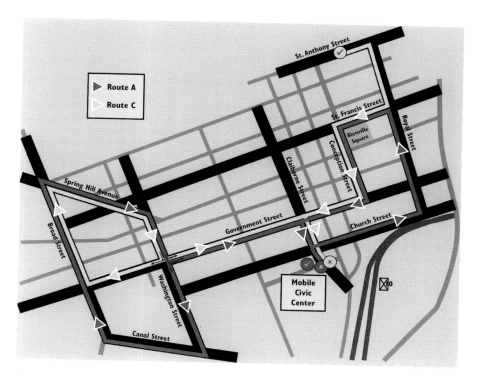

Parade routes A and C. *MobileMask.com, Nancy Joynt.*

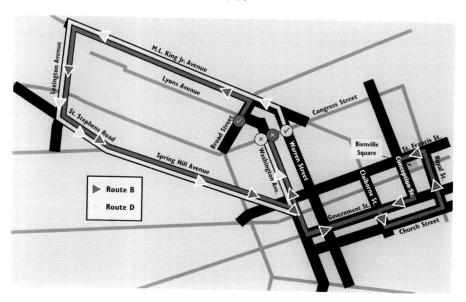

Parade routes B and D. *MobileMask.com, Nancy Joynt.*

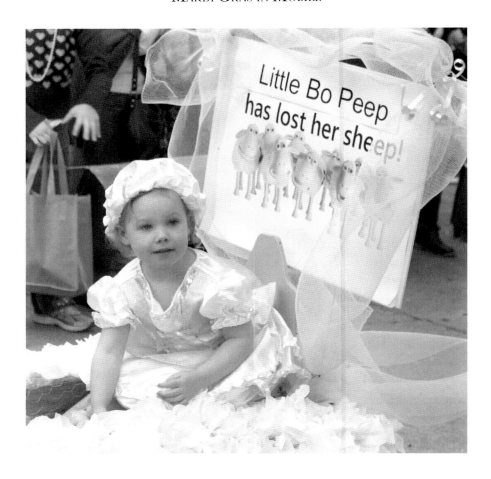

A little girl in the Mystics of Ashland Place Children's Parade, 2014. *Ashland Place United Methodist Church Collection.*

Chapter 8
Joe Cain Day

Have you heard the expression "raise Cain"? It may originally come from Cain in the Bible, but we in Mobile have reason to claim the phrase, as we "raise Cain" from the grave each Sunday before Mardi Gras Day.

It is the daylong celebration of the man credited with reviving Mardi Gras after the Civil War, Joseph Stillwell Cain. This celebration is called the People's Celebration because there are no private mystic societies or Royal Courts involved. As many as 150,000 people pour into downtown Mobile to pay homage to this beloved Mobilian with ceremonies, parties and the largest parade of Carnival.

The celebration begins with Joe Cain's Merry Widows arriving at the Church Street Graveyard at 11:25 a.m. in a bus with their chosen male escorts dressed in costume de rigueur, or white tie and tails.

The sixteen Widows, dressed in full nineteenth-century black funeral attire with full black veils, proceed while wailing and faking fainting spells, as they make their way through the gated entrance to Joe Cain's grave site just inside the graveyard walls.

The Widows all have make-believe names on nameplates on top of their veiling. They stay in character all day long, and one of my favorite Mardi Gras treats is to speak at length to any of these ladies whose real identity is today's best-kept secret of the Carnival season.

On the group's website (http://cainsmerrywidows.org), a few describe their relationships with Joe:

"THE NIGHT BEFORE LUNDI GRAS"
A widow's lyrical play on the second coming of Joe Cain

Twas the eve of Lundi Gras, when all through the house
We were busy preparing to mourn our dead spouse.
Mobile slept after a night's celebration
Of Mardi Gras, the oldest in the nation.

Beads hung from power lines, Moon Pies littered roads
As we grieved at the grave of our beloved beau.
The widows of Joe Cain congregate once a year
To march Church Street to Oakleigh to honor our dear.

It's a tradition most know little about
And a story that some even question and doubt.
Our goal is to remain somber and genteel
As wives of the man who revived Mardi Gras in Mobile.

We cry and we wail as we pay our respects
And dress all in black for dramatic effect.
Then we take to the street for all to watch and cheer
Such a sight that Chief Slac would surely revere.

—Elyzabeth Wilder
February 2014, MobileBayMag.com

Sue Ellen: Joe was the love of my life—he died in the featherbed with me in his arms. We met in Bienville Square on a Sunday afternoon. He asked me to stroll, and by the evening, he was hooked! Other widows say it was my biscuits that killed him, but they are just jealous of the attention Joe gave me—he really and truly loved me the best!

Scarlet: No matter what all these hussies say, I am and always was his favorite! But I was not always a prim and proper lady. With a name like Scarlet, Joe had to keep me under wraps constantly, because I am a spitfire! I continue to be one, though I am a lonely widow. Boo hoo!

Samantha: I am a dispenser of war garters—much to Joe's consternation. He was quite vexed when I lifted my skirt to allow a gentleman to appropriate one of my garters. I could hear his groaning from the grave! I shudder, but that didn't stop me because I am really lonely. I miss Joe, but I continue to sew garters yearly. They are definitely to honor my Joe in my own special way!

Emmy Lou: I was Joe's favorite, even though I wasn't his first wife. I am the smallest of all his wives, but he always said dynamite comes in small packages—we are talking TNT! I sure miss our explosive times together!

Pearl: I was his REAL GEM. He wore a pearl stick pin [sic] on his tie just to remember me, because I was so sweet to him. Joe and I loved to dance in the parlor—real close!

Zelda: Y'all know that Joe loved me best! Joe and I spent many evenings together, sitting beside the blooming azaleas on the porch. Every spring when they bloom I get a little sad for the loss of my dear Joe. I perk right up when I think about how deluded the other widows are—they really think they were his favorites. If they would slow down on drinking those Mimosas, they would all realize that I was Joe's favorite!

Tara: Joe picked me as his favorite. You will hear others say they were his favorite but don't believe them. I kept Joe happy during his declining years. We both disliked those damn Yankees who invaded our beautiful South!

Savannah: I hail from Georgia, and I was, without a doubt, Joe's favorite. Joe used to say that I was just as sweet and juicy as those fine peaches he used to enjoy eating out of the palm of my hand. Just thinking about it makes me miss him even more, but I have to go on to keep his memory alive and to celebrate the time I did have with him!

Georgia: I was the peach of Joe's eye, there was no greater romance than ours. Joe was inspired by me to celebrate life, and that led to Mardi Gras being reborn…I will always love you Joe! We will keep your memory alive, Sugar! Rest in peace!

Gertrude: I was one of Joe's younger wives. All those children we had were enough to prove I was his favorite! I remember when those dreadful Yankees

tried to dampen our spirits; Joe and I got out in the streets and showed everyone how to have a party! He lived and he loved only the best! Here's a toast to you Joe, you will never be forgotten!'

Salome: I was the comfort and joy of Joe's later years—saving and protecting him from the torments of those harpies—the OTHER wives. My devotion to him never wavers—and woe be to her who says different! I love you Joe!

Magnolia: I am Magnolia, the flower of Joe's eye. Of course he picked me right off as his favorite and exclaimed over my beauty. He loved me best because I was the sweetest. I miss you terrible Joe!

Helen: Joe was my first and last love. I was a young wife and boy did I knock his socks off. Every day to be exact. I miss his lovin' and his humor. I miss the hugs and the late night strolls in Downtown Mobile. We Widows may fight over his affection but I know how Joe loved me best. Every Joe Cain Day, I honor my Joe by having a drink (or two, three, four, five…) in honor of him. Salute!

Camellia: I was Joe's favorite. We would go down to Mobile Bay and watch the stars above. Everyone knew I was his favorite and that when they were looking for the state flower, the Governor said I know the perfect flower—Joe's sweetie "Camellia." Love you and miss you Joe!

Mary Jane: Favorite, favorite, whatever all this talk about favorites bores me. Have you ever heard the old saying "save the best for last"[?] That's me, alright. Joe would always wait until after dinner and we would go curl up on the patio and I would roll up some of his favorite tobacco so he could have an after dinner smoke, and drink of course. Bourbon was his favorite then, especially with his pipe tobacco. He could always count on me to have what he needed!

Mahalia: My Native American name "Mahalia" is what first attracted Joe to me, but after he got to know me, he knew that I was the one that was always ready to party and raise Cain!…Hell yeah, he loved me best!

Only the Widows are allowed in the graveyard, except for Mobile's great Excelsior Band, which plays "funeral" jazz as the ladies scream at one

Merry Widows' beads, 2010. *Author's collection.*

another on top of the grave, accusing the others of killing Joe by all sorts of unseemly methods. Throngs of onlookers perch precariously atop the graveyard walls and teeter on ladders, trying to view the oddest tradition of Mobile's Carnival.

Before long, the Widows begin laughing, throwing their hands in the air and tossing their beads and black roses to the crowds on and beyond the walls. Only these ladies may throw black beads and black roses at Mardi Gras. Catching their emblem beads, which are black discs that read "Cain's Merry Widows," is said to be good luck.

The Widows board their bus and head to Joe Cain's original home at 906 Augusta Street in Oakleigh Historic District. Here, for decades, each owner of the home has invited the ladies in for cocktails. The current owner, John "Hap" Kern, enjoys continuing the tradition opening his house each year to the Widows, his friends and throngs of onlookers who crowd the street to get a glimpse of the joyful occasion.

At 12:20 p.m., the mourning ladies leave the home and head downtown, where they disperse, placing beads around the necks of often-startled tourists. They have no idea what these strangely dressed women—a couple of whom may not be women at all—are up to!

As the throngs pour into downtown, the excitement builds in anticipation of the longest parade of Mardi Gras: the People's Parade! At 2:30 p.m., the parade begins on Route A, the popular two-and-a-half-mile route that twists and turns through the Central Business District.

At the same time, another secretive group of women will also be converging on downtown Mobile. These women lead the parade. Introduced in 2003 and organized by one of Joe Cain's great-nieces, these are the Merry Mistresses of Joe Cain. They, too, dress in nineteenth-century funeral attire with heavy veiling. The difference, however, is that their dresses are cut to just above the knee, and all of their attire, head to toe, is fire-engine red!

These ladies also have Old South make-believe names, but these names are a little racier, such as Zora, Jezzie, Belle, Ruby and Gizelle. They carry dozens of red roses, which they toss to the delighted crowds.

The Mistresses are not allowed in the graveyard at the time of the Widows' 11:25 a.m. visit, but they sneak in later in the afternoon, after the parade, to throw their red roses on Cain's grave in the Church Street Graveyard.

As the giant Route A parade begins at 2:30 p.m., the Merry Mistresses prance along. They are first, followed by Chief Slacabamarinico (Joe Cain), portrayed by locally revered Bennett Wayne Dean Sr., a Methodist minister and author. He stands atop a replica of the coal cart used in the original

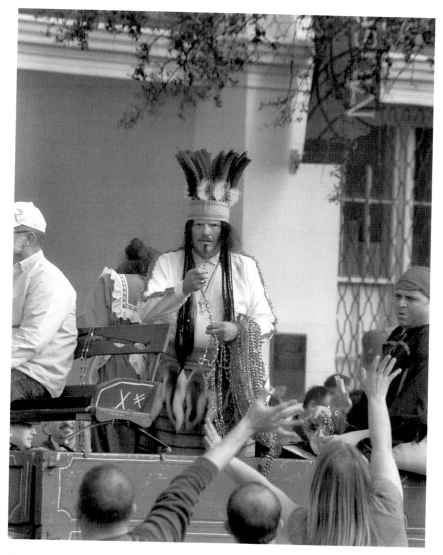

Bennett Wayne Dean Sr. as Chief Slacabamorinico in the Joe Cain Parade, 2010. *Author's collection.*

parade of 1866. Following the chief are all the Widows on the "funeral" float, tossing black beads and black roses to the crowd.

Throngs of floats follow the Widows. Some are elaborate and painstakingly executed by local families, groups of friends, businesses, churches or schools. Some are simply flatbed trucks with local bands

Above: Joe Cain's Merry Widows funeral float, 2010. *Author's collection.*

Left: Joe Cain Parade, Knights of Daze float, 2010. *Author's collection.*

of all types. The parade is truly a representation of its given name: the People's Parade.

The parade lasts all afternoon due to its size. The following is a current, yet partial, list of the floats and their fun-loving creator's names: Society of Bums, Dauphin Street Drunks & Head Wench Girls, the Wild Mauvillans, Cain's Merry Widows, the Cain Raisers Society, the Trolley Society, the Mistic Order of Moonpie, the Mystic Order of Pi, Cain's Jolly Jesters, the Webb-O-Bunch, Joe Cain's Coal Wagon, Fowl River Little Rascals, Tombstone Kids, Knights of Daze, the 2001 Society, Friends of Joe Cain, the Clown-Arounds, Joker's Wild, the Mystic Order of Dead Rock Starz, Cain's Order of Blue Bloods, Mystic Cain Raisers, Knights of the Ket, Court of the Mornin' Afta, Johnny's Rowdy Friends, the Krewe of Azalea, Joe Cain's Misfits, the Cowbell, Rake & Hoe Society, the Sons & Daughters of Joe Cain, the Chickasaw War Party, the Krewe De La Black Beard, the Crewe of Cains, Hurri-Cain's, the Order of Khaos, Friends in Low Places, Krewe of Sugar Beads, Isle of Cain, Cain's Twelfth Night Society and the Old Slag Beer Drinking Society.

Along the route, the Widows and Mistresses are likely to break line and get into a catfight or two with one another, with accusations of all kinds thrown about, including poisoning or even murder. The Mobile Police have been known to add more fun to this great street theater by "arresting" a few of these unruly women.

Recently, a new party has been created called the Joe Cain Foot Marchers Ball, which allows even out-of-towners to feel they are a part of the action. It is hosted by the Joe Cain Marching Society. Problem is, it is in June!

Before you can catch your breath, another parade hits the streets at 5:00 p.m. La Krewe de Bienville is the only mystic organization formed for visitors to ride on a float and attend a Mardi Gras ball. You can simply purchase tickets through the organization. To ride on one of the group's floats is extra special because the parade attracts the largest crowd, other than Mardi Gras Day, of Mardi Gras revelers downtown.

Often, if other parades have been rained out prior to this Sunday, they are placed after the La Krewe de Bienville parade. This creates even more excitement, as parades may last several more hours.

This day of the Joe Cain Parade, or People's Parade, and the La Krewe de Bienville parade, which offers visitor participation, is truly a day of inclusion.

Chapter 9
The Royal Courts

This is a time of changing values and customs and the days of the opulent Debutante Balls are over, probably forever.
—N. Jack Stallworth, 1973

Little did Mr. Stallworth know that royal affairs, including the royal coronations, dinners and luncheons, would include more elaborate settings and more participation than any time in history by the end of the twentieth century.

Mobile has two Carnival associations that select participants and schedule the royal coronations, receptions, dinners, luncheons and other parties for the members of the Royal Courts and their families. Most of these events are just before Mardi Gras Day, but a few take place months before.

Mobile's oldest Carnival association is the Mobile Carnival Association, founded in 1872. With a membership of several hundred, the MCA has fourteen board members, including a chairman; however, there are as many as seven emeritus members of the board. There are seven officers, including a president, who conducts donor solicitations. He is aided by several vice-presidents.

The Mobile Carnival Museum is run by the MCA, in a building owned by the City of Mobile, under a separate board of directors but with the same executive director, Judi Gulledge.

Committees of the MCA include the Isle of Joy Trip, the Coronation, the King's Supper, the Queen's Luncheon, the Court's Supervision, the

Fat Tuesday Party, the Camellia Ball Reception, the Floral Parade and the Military Escorts.

Selection of the MCA's court begins in the spring, and the season starts on Thanksgiving weekend, when a group of young ladies are selected for their debut at the Camellia Ball. Mobile is the only city in the country where debutantes wear pink rather than white.

Most, if not all, of the debutantes of Mobile will become ladies of the MCA Royal Court, and one will be chosen the following May to be Queen. The King is also announced at this time. The MCA's Royal Court consists of a King and Queen, twenty to twenty-four Knights and Ladies of the Court, including as many as four special Ladies in Waiting to the Queen. These young people are usually in their early to mid-twenties.

There is a Juvenile Court of young teenagers, which includes a King and Queen, as well as about ten Knights and ten Maidens. Two young men in this age group will be chosen as "military" escorts to the Juvenile King and Queen. Five- and six-year-old boys serve as Heralds, Equerries and Pages. Heralds pretend to blow bugles at the start of the coronation, Equerries carry the Queen's crown and scepter on pillows next to the King as he is introduced and Pages ensure the proper flow of the King's and Queen's trains as they proceed on the coronation floor to their throne.

During the year, the Royal Court has thirty-five or so parties that include teas, receptions, theme parties, an Old Court–New Court Party on the Friday before Mardi Gras Day and the Calling on the Queen Party held the Saturday before Mardi Gras Day.

The coronation of the Queen of the MCA is held on Saturday evening before Mardi Gras Day. The affair begins at 6:30 p.m. and is open to the public, with tickets acquired from the Mobile Carnival Association at no charge.

The setting for the coronation is that of an opulent throne room, and the event takes place at the Mobile Convention Center. Mobile's premier set designer, Ron Barrett, creates a truly regal atmosphere befitting the royal occasion. The Mobile Area Mardi Gras Association's Queen will be crowned here the following evening.

Kathryn Taylor deCelle beautifully describes the Mobile Carnival Association's Coronation in the book *Queens of Mobile's Mardi Gras*:

> *Guests view not a stage but a throne room with large white columns on either side of a terraced stage. Centered a number of steps higher is the throne. Above the throne is an imposing gold crown, from which hang gold lamé draperies. Between the columns are placed the six flags under which*

Mobile has lived during her colorful history. Crystal chandeliers, eight-foot candelabra, and a profusion of palms, give the backlighted stage a brilliant and elegant appearance.

Promptly at the appointed hour, the lights are dimmed, and to the stirring traditional background music from Verdi's Opera "Aida" the magnificent pageant begins to unfold.

The Military Escorts to Their Majesties first enter the ball. Then the Knights of the Court march in, two by two. Heralds proclaim the arrival of His Majesty, King Felix III, who is announced by Royal fanfare. Preceded by his two Equerries carrying the crown and scepter on satin pillows, the King circles the auditorium, saluting the guests and reveling in the applause of his loyal subjects. Followed by his Pages, who wear his Royal colors, he takes his place in the throne chair to await his Queen.

Then begins the promenade of the Maids and the Ladies-in-waiting to the Court. One by one, each is announced and proceeds to the throne where she is met by her Knight. Together they pay homage to His Majesty and then take their appointed places either side of the Royal throne.

Then the great moment arrives! The music stops—there is a pause—the trumpets signal the approach of the Queen. As the traditional music resumes, the subjects of her mythical kingdom rise, and the Queen moves forward. She is dressed in regal splendor—a sparkling gown with a dazzling jeweled collar, and robed in ermine trimmed glistening velvet mantle. Slowly…so all may marvel at the magnificent train and gown…she circles the arena making her way to the throne of Felix III, where she kneels to be crowned the Queen of Mardi Gras before taking her place beside her King.

The ladies in the Court, escorted by their Knights, pay their respects to the King and Queen. The King's Chamberlain comes forth and proclaims, in the name of the Majesties, a period of Misrule and Joy for All.

Immediately following the formal ceremonies, family, friends, and honored guests go to the stage to offer congratulations and good wishes to the King and Queen and members of the Court. Following the Coronation, the King entertains his Queen and the Royal Court at the customary state dinner, the King's Dansante.

Thus Mobile celebrates the highlight of her historic Mardi Gras season. The Coronation of the Queen, unique to Mardi Gras in Mobile, is one of the City's most beautiful traditions and customs. Once more a Mardi Gras Queen is crowned in splendor. She then takes her place forever in the long history of Mobile's succession of Queens of Love and Beauty and Make Believe.

Few changes have taken place since this description of MCA's coronation was written. One important addition in recent years has been the introduction of the Mobile Area Mardi Gras Association's King and Queen as part of the coronation. They will make their way around the coronation floor and bow to the MCA's King and Queen. Likewise, the MCA's King and Queen do the same at the MAMGA coronation.

To this day, two military escorts will escort our Queens for five days through Mardi Gras Day to luncheons, receptions and parties. Even at the women-only luncheons, they will be seated to the left and right of the Queen and will be the only men in the room.

The escorts, selected by Carnival association committees, must be able to ballroom dance, socially drink (but not too much) and speak proper English. The young men are most often from the U.S. Marine Corps or the U.S. Navy and will perform their duties in full military dress. Mobile always enjoys having at least one navy ship in port for Carnival. The escorts may be selected from a visiting ship, from nearby bases or from relatives of MCA or MAMGA families in the armed forces.

In her earlier description of the coronation, deCelle refers to the customary state dinner after the coronation as the King's Dansante. This dinner is now referred to as the King's Supper.

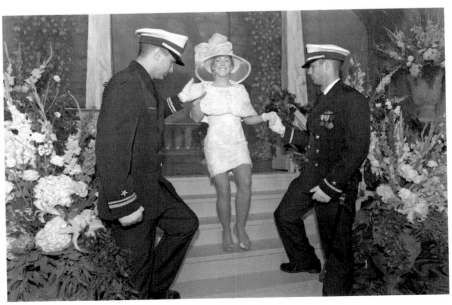

Military escorts with Queen Madeleine Maury Downing, 2014. *Photo by Jeff Tesney, Mobile, Alabama.*

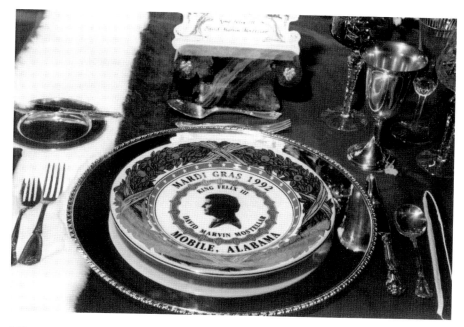

MCA King's Supper place setting honoring King Felix III, David M. Mostellar, 1992. *Photo by M&A Studios, Mobile, Alabama.*

Most guests at the King's Supper are invited by the King's family; however, the public may purchase tickets from the MCA for $125.00 per person. This extravagant dinner is more a feast for the eyes than the stomach. The table set for the Royal Court is dazzling. It is often designed by Ron Barrett. I recall the King's Supper of David M. Mostellar with six-foot ice obelisks, giant floral arrangements and place settings that included custom-made china, including dinner plates on which appeared an impression of the King's profile.

After the grand affair, the King and Queen will travel to the Comrades Ball at 1:00 a.m., where they will be introduced at one of the oldest African American balls in Mobile.

The following Monday, the MCA Queen will host the Queen's Luncheon at noon, the day before Mardi Gras. This luncheon is often theatrically designed by such talented designers as Homer McClure and Ron Barrett. This is another over-the-top affair, with three hundred or more guests, where the Queen will present gifts to the Ladies of the Court. These gifts may be oil paintings, glassware, silver mint julep cups or porcelain objects such as Mary Kirk Kelly white pumpkins in purple velvet hatboxes from 2011 Queen Lynn Wentworth Morrissette to her Ladies of the Court. The

Knights appear during the luncheon to present their respective Ladies with giant stuffed animals, a tradition that started many years ago. The Juvenile Court King and Queen will also make their appearance with their young escorts, who are presented to the Queen. Then they exchange gifts.

The tables of the luncheon are often so densely filled with lovely flower arrangements that the ladies may not be able to see guests seated across the table. Table settings may consist of heirloom china that the Queen's mother or grandmother may have used at their luncheons as Queens. Napkins may be embroidered with gold and silver thread, and crystal may be by Baccarat or Tiffany.

The Queen's Luncheon is where you will see another display of amazing hats. Wearing elaborate hats bordering on the bizarre is a long-standing tradition in our city. So, if you are lucky enough to be able to attend, do not forget your hat!

The public is invited to the Queen's Luncheon at a cost of seventy-five dollars per person. Tickets are available through the Mobile Carnival Association.

The Mobile Carnival Association sponsors several parades during Carnival season. Its Floral Parade rolls on the Saturday before Mardi Gras Day and again the following Monday.

On Monday, the MCA's King arrives at the foot of Government Street, at which time the mayor of Mobile reads a proclamation and presents the King with a key to the city. Then the King and the Knights mount their floats and join in the Floral Parade as it passes on Royal Street.

The floats of the Floral Parade are designed with children in mind, emphasizing happy, youthful themes. The floats on which the Juvenile Court rides begin the parade followed by floats sponsored by various civic groups.

One recent year featured floats that were designed with themes of present and past popular games, such as chess, checkers, jacks, marbles, Monopoly and Pac-Man.

On Mardi Gras Day at about 1:00 p.m., the King's Parade rolls. At this time, the King will now be joined on his float by the Queen, with their beautiful trains draped behind them. Preceding them will be the Knights' floats and King Felix's Maidens, last year's Ladies of the Court, on their beautiful swan float.

The following is the story of Felix's Maidens by Edward Ladd:

Little has been found in the written annals of the fun loving and joyous group of young ladies only known as "Felix's Maidens." After a great deal of research taking many hours of poring over little known documents, obscure pamphlets, laborious reading, and a fantastic imagination, it has

Ladies at the MCA Queen's Luncheon, with Queen Madeleine Maury Downing, center, 2014. *Photo by Jeff Tensey, Mobile, Alabama.*

come to light that this group does exist on the Isle of Joy—the now famous and mysterious home of our noble King Felix III.

Being the noble and benevolent monarch that he is, he took it upon himself to be assured that his subjects were always protected in and out of the kingdom. Felix endeavored to find the best protectors for these lovely young Maidens. After researching mythology and other resources, he settled upon the graceful swan. While these gorgeous creatures are traditional symbols of grace, beauty, and charm, they are very strong, protective, and are very good at sensing danger. In mythology swans are depicted as pulling the chariot of Apollo and were sacred to Aphrodite, the goddess of love. Therefore when he travels away from the Isle of Joy and is accompanied by the Maidens, he has in his entourage, a lamentation of swans.

Being the master of magic and make-believe this lamentation is not visible to the naked eye, but they are ever present and keep a constant eye on his entire company of revelers.

And now you know…the rest of the story.

The Mobile Area Mardi Gras Association was founded in 1938. MAMGA is the historically African American Mardi Gras association. The association selects a King and Queen, as well as twelve to eighteen Knights and Ladies. Ages of the court's participants vary, but they are usually in their mid- to late twenties. A Junior Court is also selected. These young people, usually high school students, include a King and Queen and twelve to fourteen Knights and Ladies. There is also another group of younger participants, usually eight or so years old, who serve as "Children of the Court" and have duties at the coronation.

The MAMGA Courts are very busy during Carnival season. Just as the season starts, the Junior Court Royal Coronation, when the young King will crown his Queen, is held two Sundays before Mardi Gras Day. The Junior Court will hold the Junior Monarch Royal Luncheon at 11:00 a.m. on the Saturday before, usually at the Battle House Hotel. The public is invited at forty dollars per person. Tickets are available through MAMGA.

MAMGA also selects a Grand Marshal of Carnival. He is often an older, respected gentleman who has given much of his time to the betterment of the community. There is a private Grand Marshal's Party that precedes the Grand Marshal's Ball. At the Grand Marshal's Ball, the Royal Court is introduced to the public for the first time. The grand affair is held on the Friday evening before Mardi Gras Day and is open to the public for fifty dollars per person.

A private Queen's Party is held on the Saturday before Mardi Gras Day for about five hundred guests.

On the Sunday prior to Mardi Gras Day, the MAMGA King, known as Elexis I, arrives from the Isle of Joy, as mentioned before, a make-believe place somewhere on distant shores. At the foot of Government Street, prior to the King boarding the royal motorcade, just as with the MCA King Felix III, the mayor of Mobile presents the King with a key to the city, after which he reads a proclamation honoring the King, Queen and their Courts as important parts of Mardi Gras history.

The royal motorcade proceeds west on Government Street to the Gulf City State Lodge, where the new Grand Marshal receives the key to the city from the preceding Grand Marshal or a city council member. Here, too, the Striker's Social Club presents the King and the Court to the public (the Queen will be crowned later that evening).

Sunday evening is the MAMGA Royal Coronation. This is where King Elexis I will crown his Queen in an extravagant setting in Mobile's Convention Center at 7:00 p.m. The ceremony is rich in tradition. At the beginning, the

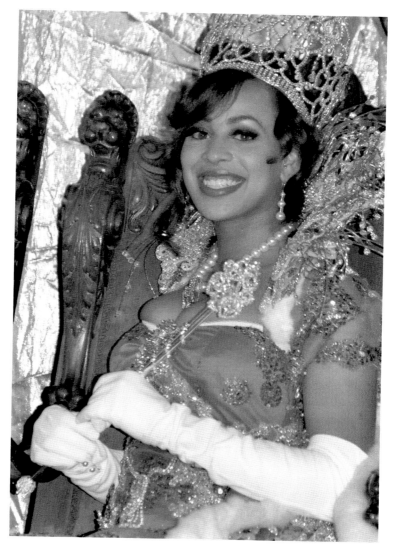

MAMGA Queen Cecile Frances Green, 2014. *Author's collection.*

young Children of the Court will appear as Heralds. These young men pretend to blow bugles as the music begins. The Knights appear in their Renaissance-style costumes and make their way to the stage. Next, in extravagant robe and train, King Elexis I appears with his young Equerries, holding the Queen's crown and scepter on pillows. Then, one by one, the Ladies of the Court appear in their lovely gowns and trains. Last, with her Pages, the Queen makes

her entrance, while music of pomp and circumstance fills the beautiful room. The Queen is crowned by King Elexis I, and they take their thrones. King Felix III and the Queen of the Mobile Carnival Association are introduced and bow to the MAMGA King Elexis I and his Queen. A royal family photograph of the MAMGA Court is then made, after which the Knights and their Ladies line up on the coronation floor, where the public may approach and take photographs. This grand occasion is open to the public for ten dollars, and tickets are available through the Mobile Area Mardi Gras Association.

For fifty years, the following proclamation was read at the MAMGA coronation by Dr. Wilborne L. Russell, and ever since, it has been read by a young courtier to the King and Queen.

Here ye, here ye, here ye, the following proclamation introduced by the Grand Marshal at a double session of both houses on the 4th night ago in the east room of the upper chamber of the Royal Palace.

Now becomes the law of the homeland and for all the kingdoms beyond the sea, whereas the honorable ruler King Elexis set on Mobile soil today after having been drawn aboard because of urgent matters at state. It is so worth of doing honor to him.

Beginning at the stroke of midnight, his Royal subjects are to forget their cares and worries and release their selves from the shackles of obligation and give in to their emotions of pleasure and merriment. Tomorrow all schools and district offices will recess. Masking, parading, eating, and dancing will be the order of the day. This will end when Ash Wednesday begins.

This proclamation is signed by all the members of the Royal Cabinet and the members of the Mobile Area Mardi Gras Association.

Monday before Mardi Gras Day, or Lundi Gras (Fat Monday), MAMGA holds a Royal Luncheon, also open to the public at forty dollars per person at the Battle House Hotel. Later that evening, a private King's Party is held for over five hundred persons.

Then, on Mardi Gras Day, King Elexis I and his Queen, in full regalia, along with their court, appear in the longest organizational parade of Mardi Gras: the Mammoth Parade. Often consisting of thirty-six floats, the Mammoth Parade is a production of MAMGA and is the last daytime parade on Mardi Gras Day. The parade starts with the Emblem float, followed by the Royal King and Queen float, Junior King and Queen float, Junior Court float and MAMGA members' floats, sponsored by different organizations, all separated by marching bands.

Mobile Mardi Gras costumes have drawn national attention. On a recent trip to Mobile, the costume manager for the popular Broadway show *Wicked* visited the Mobile Carnival Museum at 355 Government Street in downtown Mobile. He was enamored of the beautiful gowns, robes, trains, crowns and scepters worn by our Royal Courts. Taking more than one hundred photographs, he said, "I cannot wait to get back to New York to show my Broadway friends these incredible pieces of wardrobe art!"

As mentioned earlier, the public is invited, sometimes for a small admission price, to the coronations of the Royal Courts, or they may visit the Mobile Carnival Museum, where as many as thirty-five royal ensembles, as well as many mystic society costumes, may be admired.

The Ladies of the Courts are announced before Christmas and Kings and Queens in May. This timeframe gives the designers, with their teams of beaders and seamstresses, time to perform in the next few months what some would refer to as a miracle.

In terms of costume making, the requirements of the Knights of the courts are relatively easy. Their costumes are permanent, at least until they wear out. Many are stored at the Carnival Museum until their appearance in the coronations and parades during Carnival season.

The Kings wear robes, which are elaborate outfits often designed with a theme, such as Napoleon or Louis XIV. Their trains, which are fifteen feet or longer, and trailing capes may weigh up to 120 pounds and are often covered in crystals and antique fur.

The Queens wear gowns and have trains, which may also have themes and are equally elaborate as the King's ensemble. In addition, the Queens wear a mantle. This is a highly decorative raised collar, which may weigh up to seventy pounds, that sits on the Queen's shoulders. The mantle comes from a tradition started by the Queen of Great Britain in the late 1600s. All trains include artistic interpretations of important aspects of the royals' lives, such as fraternity or sorority crests, sports logos or mascots, professional symbols and family crests.

Both the Kings and Queens wear crowns and carry scepters, which are mostly newly made each year, custom-designed for each new King and Queen to his or her liking, with authentic crystals and birthstones.

Ladies of the Court, as well as the Maidens of the MCA Court and Junior Ladies of the MAMGA Court, wear gowns with trains. Often, trains of the Ladies are a little smaller than the Queen's, and the trains of the Maidens and the Junior Ladies are a little smaller than those of the Ladies. The Ladies in Waiting, usually four or fewer in number and who enter the coronation just before the Queen, may wear mantles and crowns like the Queen.

Some of our early royal costume designers were Mrs. Fanny Elsworth, Mrs. J.S. Hale Sr., Mrs. George Jumonville Sr., Edmond C. deCelle, Mrs. W.N. Owen, Jack Stallworth, Mrs. Phil Pittroff and Karen Thornton.

One of my favorite trains is that of Virginia Oliver Van Antwerp, MCA Queen in 2003. Designed by Kelle Thompson, who designed so many beautiful robes, gowns and trains over the last forty years, her train contains more than eleven thousand hand-sewn Austrian crystals. It has eleven crowns representing her eleven family members who have been Kings and Queens in the past.

As a tradition, new Kings and Queens may use pieces of their relatives' trains as part of their new regalia. In Virginia Oliver Van Antwerp's train, the border and the last two feet were taken from her grandmother's train, preserved since 1934.

One of Mobile's premier designers, Homer McClure spends many months creating beautiful royal attire each year. His talented crew of seamstresses and beaders includes Mary Funderburk, Kathy Sullivan, Maria Mattern and Deborah Andreason. Homer is one of our designers whose family has been part of the Royal Courts for generations. His mother, Louise Vass McClelland McClure, was a Juvenile Queen; his brother, Robison Clarendon McClure, was King; and he has had two nieces, Louise Vass McClure and Anna Robison McClure, serve as MCA's Queens.

Homer McClure and staff, 2014. *Left to right*: Deborah Andreason, Homer McClure, Marsha Temme and Judy Wonson. *Author's collection.*

Recently, Homer McClure shared an interesting story with me. The wife of Homer's great-uncle was Venetia Danner, Queen of the MCA in 1903. Her daughter, Mary Danner Bacon, was Queen in 1936. Her daughter, Venetia Danner Barney Prince, used her mother's train in 1959 when she was Queen, embellishing it with turquoise and silver accents. In 2005, the train spent two weeks under water during the aftermath of Hurricane Katrina. During Carnival season 2015, Venetia Prince's granddaughter Mary Danner Harmon will be a Lady in Waiting. Homer is restoring this 1936 train to reflect an empire motif of cream peau de soie panels interspersed with pieces of the original cut-velvet train.

Patricia Halsell-Richardson is another modern-day robe, gown and train designer. My favorite of her trains is the one she designed for 2014's King Elexis I, Bennie Morris Jackson Mosley. Twenty-six pelts of antique leopard, which represents the young man's high school mascot, were used to surround this eighteen-foot-long train. A hand-sculpted, three-dimensional crest is the main feature of the train. It is made of bronze, copper and citrine beaded fabrics trimmed in Swarovski crystals. There are two lion abstracts on both sides of the crest composed of metallic brocades with over 180 silver scales and a bronze and gold–beaded mane, all adorned in Swarovski crystals. Halsell-Richardson is often assisted by talented Barbara Pritchett.

Other fascinating aspects of royal Mardi Gras dress, as mentioned earlier, are the crowns, scepters, medals and pins. Local artists and designers such as Mark Callametti and Lynda Touart design many beautiful medals and pins for an array of occasions. Kings often have medals made with the year of their rule, which are given to family and friends as keepsakes of the season. The King also gives a custom-designed pin, often with precious stones, to the Queen, honoring her rule. The Queen gives pins to her Ladies as well. It is popular at royal parties to wear the pins collected from relatives and friends over the years.

Crowns and scepters have an interesting history. Originally, crowns were made with precious stones and were passed down through generations. For example, in 1903, Queen Venetia Danner (the late Mrs. J. Clarendon McClure) wore a crown made in Paris that was used by three generations. It was worn by her daughter, Mary Danner Bacon (Mrs. Howard Barney), and by her three granddaughters, Perin Bestor Bacon (Mrs. William E. Drew, Jr.), Venetia Danner Barney (Mrs. Arthur Prince) and Mary Eugenia Barney (Mrs. Martin Lanaux).

The crown of 1960 Queen Louise Morris Shearer (Mrs. Paul W. Brock) was an authentic copy of that of the Empress Josephine Bonaparte, and in

Left: Tom Van Antwerp with royal medals and pins, 2010. *Author's collection.*

Below: MCA royal medals and pins, 2010. *Author's collection.*

1970, Queen Nancy Jean Turner wore a reproduction of Queen Victoria's personal crown.

For over twenty-five years, the Dynasty Collection has been making crowns and scepters for Mobile's Royal Courts. Tommy and Tonya Cain, along with parents Jim and Jane Rhinewalt, have been making fairy tales come true for not only our Royal Courts but also for New Orleans Mardi Gras royalty and hundreds of Little Miss pageants across the country. These talented individuals provide crowns, scepters and tiaras for all sorts of pageants and celebrations in other countries as well. They are truly the crowning touch of Mardi Gras in Mobile.

Chapter 10
In Their Own Words

I asked several leaders of today's Mardi Gras what the event means to them. The following are their responses:

Mobile has been blessed with a rich culture of living life to the fullest since its founding in the early 1700s. We are not Savannah, Charleston or New Orleans…we have our own version of a wonderful port city culture. Mardi Gras means different things to different people. To me it is an inner spirit…a state of mind, a permission to relax and enjoy the moment…The Mobile Mardi Gras spirit partially explains the strong attraction that Mobile natives have to always return home. Most Mobilians who leave town to find fame and fortune elsewhere spend the rest of their lives figuring out ways to "get back home to Mobile" to enjoy the Mobile culture and lifestyle. Is it the Gulf beaches, is it the hunting camps, is it the climate or is it the "laissez les bon temps roullez" that lives in the hearts and minds of Mobilians? Mardi Gras is the energy and fun that creates Mobile magic. It is the one time of year that serious, dependable, conservative, logical businessmen and women can briefly recapture their own and release those pent-up tensions that evidently build up throughout the year trying to be respectable leaders and good fathers, mothers, brothers, uncles, aunts, employers and employees. It is our time to let loose and have good, clean fun. Let's hope that the

childish fun is still hidden somewhere down in all of us. I once had a friend who always said, "No fools, no fun!"

Now…that's what it is all about.

—David J. Cooper Sr.
Chairman Emeritus
Mobile Carnival Association

———

Mardi Gras in Mobile, Alabama, or Fat Tuesday, is the day that culminates the annual carnival season with weeks of parties, parades and formal balls that start each year twelve days after Christmas! The highlight and marquee event each year is the royal coronation of the King and Queen, Knights, Ladies and Children of the Court. The unique and salient regalia of the Royal Court each year remains a specter with the crowns, scepters and sparkling jewels and representing thousands of hours of intricate patterns designed by seamstresses for the royal attire. The city is consumed on the finale weekend with family parties in the backyards, semiformal breakfasts, brunches and royal lunches, families and friends around the kitchen tables with the best southern cuisine and gumbo on the planet. The nightly formal balls are layered with all the glitter, glamour and bright lights to dance the night away in anticipation of more of the same for the next day. Amazingly, there is a rebirth each year that is bigger, better and more elaborate that is enjoyed by all!

—Eric Finley
Past President
Mobile Area Mardi Gras Association

———

Mardi Gras has always been a part of holiday celebration in my family. My great-great-great-grandfather George C. Huggins was one of the founding members of the Cowbellion de Rakin Society, the first established mystic society in Mobile. His influence in carnival has been passed down for generations within our family.

From the time we were infants, my sisters and I were taken to parades and to watch call-outs and tableaus at the balls our parents were members of. Our family has our own designated parade-viewing spot on Royal Street.

As a young child, I thought we "owned" that stretch of the sidewalk. Aunts, uncles and cousins all gathered on parade nights, and if Daddy was feeling particularly generous, he would walk to the A&M Peanut store and buy a bag of hot peanuts to share amongst the crowd. Throwing serpentine, playing with beanbags and ogling the wares of parade vendors occupied our time until the magical parade rolled down the streets. There were no barricades back then, and we were kept at bay by flambeaus, flares and marshals who really worked at backing the crowds to the sidewalks. My thoughts were filled with catching a box of Cracker Jacks (the jackpot), a coconut Moon Pie (a rarity) and possibly a rubber ball (they would bounce down the street for blocks!). And Daddy had us all scrambling for a doubloon to add to his collection. After the fire truck passed, we would cut through Conti Street and catch the parade again on Conception Street. Then we would walk over to Government Street at Claiborne Street and catch the parade a third time. Oh, those were the days!

I specifically remember it snowing one night in the 1960s for an Inca parade. Mamma and Daddy went to the parade and left us girls at home with a sister. We were so disappointed until they returned with a bag full of throws for each of us. It never dawned on us they caught so much that night because there was literally no one adventurous enough to brave snow to watch a parade—that is, no one but the diehard Foster family. Another fond memory was watching the parades be broadcast after the late-night news. Once we were twelve years old or so, we were allowed to stay up to watch the parade on TV. It is equally exciting to see the parade again and hear the commentary. This was how I learned to appreciate the theme of parades and the artistry involved in making the magic happen. Each parade was a story unfolding.

I owe my love of Mardi Gras to my Daddy, who is still enjoying festivities even at the young age of eighty-five. He truly bleeds purple, green and gold.

—Judi Gulledge
Executive Director
Mobile Carnival Association

Once upon a time—magic—make believe—and they lived happily ever after—Mardi Gras! A great escape from the everyday life we live! We all need a little nonsense in our lives—and so we have this "great escape" called Mardi Gras.

It is a great time for those in our community to let their dreamy side go wild—and at the same time give so much pleasure to all around—and always bringing a smile to our faces. And that is the one thing that has brought me the most enjoyment to my Mardi Gras experience. Smiles on the faces—young and old. And the wonderful memories stored in their minds.

There is just something about this wonderful tradition that you cannot adequately explain to someone who has never had the experience of a Mardi Gras parade. The sirens of the police motorcycles, the marshals exquisitely costumed on their steeds, the first band—and the feet start tapping, and the hips start swaying. And there is a smile on every face!

Having the privilege of being in the design and execution of all phases of this phenomenon has brought great pleasure to me. This was truly my avocation—not my occupation.

—Edward Ladd
Curator
Mobile Carnival Museum

Carnival has been an important part of my family for generations. Well beyond participation in the courts of Carnival, we have enjoyed assisting with it for almost four decades, carrying on the tradition for others to enjoy!

We've watched "Carnival" evolve in terminology from the 1950s and 1960s term—"Mardi Gras"—and advance new traditions that have changed the face and fabric of this most enjoyable "fifth season of each and every year."

We remember events by their proximity to each Carnival and local history aligned with Carnivals as they have evolved. We remember "Lundi Gras" being introduced into Mobile and how it has grown to commonplace verbiage. We remember the Battle House before it closed and afterwards and the three decades of the Court staying at John Word's Battleship Inn on the Causeway. We remember kings with wigs, ladies of the court with red roses and the "Outside Girl" from the Spinsters calling anonymously for a callout. We fondly remember Bob Schultz, Webb Odom, Catherine Haas, Cornelia McDuffie Turner and the *Press-Register* front page proudly announcing the monarchs. We know now the evolution of full-color *ACCESS* coverage.

When I was invited to reign as King Felix III in 1977, we thought our court the largest and most exciting imaginable! Later, after two daughters reigned over Carnival festivities and having particularly exciting entourages—we

realize Carnival is continually blessed with native progeny and their out-of-town friends who continue to carry on our unique tradition. Each and every Carnival court is unique and irreplaceable. Participation is something you cannot go back and "do" like a ski trip or beach fortnight. It is something treasured for the rest of your life!

Some years ago, I was granted the title "Captain of Carnival" which gave great mirth to many friends and some family. I consider it a title of significance, which I treasure in spite of any smirks aside or otherwise.

Carnival tradition in Mobile is as engaging and welcoming as any social experience anywhere! Experiencing this beloved city of Mobile as a guest from away will encompass them into the fabric of Mobile like nothing else I can fathom.

—Robby McClure
Vice President
Mobile Carnival Association

As one of the older Mobile mystic societies is fond of saying, "A little foolishness now and then is relished by the wisest of men." What a great way to sum up Mobile's Mardi Gras for me.

My first memory of Mardi Gras, as it was for most Mobilians, was the excitement of heading downtown for the parades. Mounted on my father's shoulders as the bands and floats went by; scrambling for boxes of Cracker Jacks, beads and peanut butter kisses and comparing with brothers and friends what you had just caught; trying to dance like the Catholic Boy's Home band; "Throw me something, mister" filling the air. To me, this was always a very special time, and it still is.

Years later, my children were experiencing the same fun. As a father and adult, obviously Mardi Gras has come to mean more to me than catching throws (although I am still known to jump in front of a little old lady to grab a bag of beads). As I have become more involved in the spectacle that is Mardi Gras, I am convinced how special and unique this event is to our city; the mystic societies, the parades, the balls, the debutantes, the trip from the Isle of Joy, King Felix, etc. Sure New Orleans' is bigger and wilder, but Mobile's was the first and is the best.

One thing that has stood out for me is the memories that visitors take away from Mardi Gras. It is difficult to adequately tell an out-of-town friend

what they will experience when they come to visit for Carnival, but once they do visit, WOW! Mobile is forever remembered by them with a smile.

And, in the end, smiles are what it is all about. For the two weeks of Mardi Gras, everyone in Mobile is smiling, especially me.

—H. Taylor Morrisette Jr.
President
Mobile Carnival Association

Mardi Gras means different things to different people. As for me, it means a time for family and friends to come together by watching parades and trying to catch throws flying through the air. It's just a wonderful time of festivities and feasting.

It's also a time of fellowship and renewing old acquaintances and remembering family traditions.

—Everage Thomas Jr.
President
Mobile Area Mardi Gras Association

Bibliography

Abrams, Grace. Interview with the author. June 2014.

Alfred, Shelia. Interview with the author. July 2014.

Amos, Harriet E. *Urban Development in Antebellum Mobile*. Tuscaloosa: University of Alabama Press, 1985.

Barrett, Ron. Interview with the author. July 2014.

Brown, Robert. Interview with the author. June 2014.

Calametti, Mark. Interview with the author. August 2014.

Crawford, LuLu. Interview with the author. August 2014.

Davis-Horton, Paulette. *Avenue: The Davis Avenue Story…the Place, the People, the Memories, 1799–1986*. Mobile, AL: Davis-Horton Publications, 1991.

Dean, Bennet Wayne. *A Mobile Mardi Gras Handbook*. Chicago: Adams Press, 1967.

———. *Mobile's Illogical Woop-de-Doo*. Chicago: Adams Press, 1974.

DeLeon, T.C. *Creole Carnivals 1830–1890*. Mobile, AL: Gossip Printing Co., 1890.

DeUrrutia. Interview with the author. April 2014.

Dumas, Michael. *The History*. Mobile, AL: Zalea, 2008.

Eichold, Bert. Interview with the author. May 2014.

Eichold, Samuel. *Without Malice: The 100th Anniversary of the Comic Cowboys, 1884–1984*. Mobile, AL: R.E. Publications, 1984.

Encyclopedia of Alabama.org.

Finley, Eric. Interview with the author. May 2014.

Foster, Mildred. Interview with the author. June 2014.

Good, Gloria. Interview with the author. August 2014.

Groves, Margaret. Interview with the author. May 2014.

Gulledge, Judi. Interviews with the author. May, June, July and August 2014.

Hamilton, Peter J. *Colonial Mobile*. Cambridge, MA: Riverside Press, 1898.

Harvil, David. "Raising Cain: The Resurrection of Mardi Gras in Mobile." *Alabama Heritage Magazine*, Winter 2003.

Hayes, Walt. *Knights of Revelry—"Folly."* Pamphlet self-published by author.

Hearin, Emily Staples. *Let the Good Times Roll.* Mobile, AL: self-published by the author and William Buck Taylor, 1991, 1996.

Hearin, Emily Staples, and Kathryn Taylor deCelle. *Queens of Mobile Mardi Gras, 1893–1986*. Mobile, AL: Sipco Inc., 1986.

Hill, Hayley. "Anatomy of a Train." *Access* 6, no. 2 (April 2014).

Inge, George. *O.O.M.—Our Book of State.* Mobile, AL: Southern Lithographing Co., 1968.

Jones, Julie Andrade. Interviews with the author. July and August 2014.

Joynt, Nancy. "Parade Routes of Mobile." In *Mobile Mask, Vol. 2*. Mobile, AL: published by the editor, Steve Joynt, 2014.

Joynt, Steve. Interviews with the author. July and August 2014.

Kruthers, Kay. Interview with the author. Various dates in 2014.

Ladd, Bradford. Interview with the author. July 2014.

Ladd, Edward B. Interview with the author. Various dates in 2014.

Lovett, William J., Jr. *Mardi Gras in Mobile: A Chronicle of Black Participation.* Mobile, AL: Mobile Area Mardi Gras Association, 1980.

Lynn, Sharon, and Robert James. *All About Mardi Gras*. Abilene, TX: County Road Publishing, 2012.

"M.A.M.G.A., a History." MAMGA.org/history.html.

"Mardi Gras in Mobile, Alabama." http://en.wikipedia.org/wiki/MardiGras_in_Mobile,_Alabama.

Masked Observer. "Mardi Gras: Order of Osiris Fabulosity." *Mobile Press-Register*/AL.com. February 14, 2011.

McClure, Homer. Interview with the author. July 2014.

McGehee, Tom. Interviews with the author. May and September 2014.

McVay, Chuck. Interview with the author. July 2014.

"Mobile Mardi Gras 2010." http://en.widipedia.org/wiki/File:Mobile_Mardi_Gras_2010_13.jpg.

"Mobile Mask." http://TheMobileMask.com.

Mostellar, Rhea S. Interviews with the author. April, July and August 2014.

Mussell, Steve. Interviews with the author. August and September 2014.

Prince, Venitia. Interview with the author. August 2014

Rayford, Julian Lee. *Chasin' the Devil Round a Stump: A History of Mardi Gras, 1794–1962*. Mobile, AL: American Printing Co., 1962.

Richardson, Patricia. Interview with the author. September 2014.

Schmohl, David. Interviews with the author. July, August and September 2014.

"Second Line Parades." http://en.wikipedia.org/wiki/Second_line_(parades).

Stephens, Craig. Interviews with the author. August and September 2014.

Strikers, Historian of. *A History of the Strikers, 1842–1997*. Mobile, AL: self-published, 1997.

Tallant, Robert. *Mardi Gras*. Gretna, LA: Pelican Publishing Co., Inc., 1947–1948.

Thomas, Evarage. Interview with the author. June 2014.

Thomason, Michael, and Jay Higginbotham. *Mobile: The New History of Alabama's First City*. Tuscaloosa: University of Alabama Press, 2001.

Toomey, Steve. Interview with the author. July 2014.

Van Antwerp, Tom. Interview with the author. August 2014.

Wilder, Elyzabeth. "The Night Before Lundi Gras." *Mobile Bay Magazine*, February 2014.

Withers, Thomas. Interview with the author. June 2014.

Index

About the Author

L. Craig Roberts has been living in Mobile for forty years. He was born in Guntersville, Alabama; grew up in Gadsden, Alabama; and received a bachelor of architecture from Auburn University in 1975.

He has practiced architecture in Mobile for thirty-six years, specializing in high-end residential projects.

Roberts fell in love with Mobile's extraordinary historic architecture and colorful Mardi Gras. He gives lectures on both subjects, as well as leads city architectural tours and tours of Mobile's Carnival Museum.

His architectural work has appeared in two books: *Twenty-First Century Homes: Innovative Designs by America's Leading Architects* and *Contemporary Southern Homes*. Three of his projects were featured on HGTV, and his work has appeared in magazines such as *Better Homes and Gardens* and *Southern Living*.